HERTFORDSHIRE
The Way We Were
in the Forties, Fifties and Sixties

GW00646221

Richard Whitmore

COUNTRYSIDE BOOKS
Newbury, Berkshire

COUNTRYSIDE BOOKS
3 Catherine Road
Newbury, Berkshire

To view our complete range of books,
please visit us at
www.countrysidebooks.co.uk

ISBN 1 85306 755 5

Produced through MRM Associates Ltd., Reading
Typeset by Techniset Typesetters, Newton-le-Willows
Printed by Woolnough Bookbinding Ltd., Irthlingborough

CONTENTS

Introduction

It was Festival of Britain Year – 1951. To a lad of 17, fresh from school, the great Dome of Discovery and the graceful cigar-shaped Skylon, apparently floating in space over the Festival Gardens at Battersea, seemed to signal an end to the austerity of the previous decade and herald exciting prospects for the second half of the 20th century.

The post-war recovery did not happen overnight, though. Rationing, identity cards and National Savings stamps were still in evidence and those of us from the lower-middle and working classes were still having to 'make do'. The brown tweed suit that I wore for my interview at the *Hertfordshire Express* was second-hand, purchased by my mother for £1 10s 0d (£1.50) from a friend whose son had outgrown it. My brown leather brogues were the only pair of shoes that I possessed. Clothes rationing meant that, apart from an occasional new pullover or Aertex summer shirt, I had been dressed seven days a week in the grey, navy and gold of Hitchin Boys' Grammar School.

In the pocket of my interview jacket was my Oxford School Certificate, awarded in 1950, the year before the General Certificate of Education was introduced. It contained sufficient 'credits' to qualify me for the entrance examination to Oxford University. But undergraduate places were few and far between in those days, as were universities; so after a couple of terms loafing around the Lower Sixth I had reached

The Festival of Britain symbol.

the decision (warmly endorsed by the staff) that my academic career had reached its zenith and it was time to look for a job.

The *Express's* editor, E.W. Hodson, Hoddy, as he was affectionately known, had worked on the newspaper since 1910 and was approaching the end of his career. A gentle man, he was one of that near-extinct breed who, throughout his life, had only ever addressed male acquaintances by their surname, as though still at school. 'Good morning, Whitmore. I'm Hodson.' His face wore a permanently anxious expression, emphasised by long grey eyebrows that twirled up over the frame of his horn-rimmed spectacles. Always immaculately dressed, he had a penchant for polka-dot bow ties.

He settled down to grill me. First, my School Certificate results. I handed the certificate to him and he ran his eyes down the list. 'Credits in English Language and English Literature. Good. Good.' Why did I want to become a reporter? And how did I see my career developing? 'Assuming I can make the grade, I think I would like to work for the *Times*,' I replied smartly, having seen the folded newspaper on his desk was the *Times*.

As Hoddy beamed, so I became slightly worried. Would this bold statement of ambition provoke a series of penetrating questions on international affairs, about which I knew nothing? Modern history and economics had not featured in the curriculum for B-stream boys so, when I left school, traumatic world events like the distant war in Korea meant little to me beyond prompting the occasional

National Savings publicity.

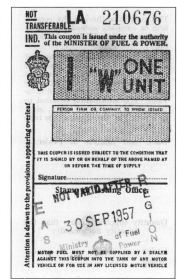

During the Suez crisis of 1956-57 Britain's motorists found themselves being issued with petrol coupons once again when the Ministry of Fuel brought back petrol rationing. It lasted only a few months.

worrying thought that if the Chinese hordes didn't pack up and go home soon I might have to spend my two-year period of National Service out there. The prospect of becoming one of the 1,500,000 United Nations servicemen killed or wounded during that encounter never entered my mind.

My knowledge of news on the home front was pretty limited, too. I do remember having a sneaking regard for the audacity of the three Scottish Nationalists who broke into Westminster Abbey on Christmas Day and pinched the Stone of Scone from beneath the Coronation Throne, but that's about all. Fortunately there was no invitation to discuss that or to speculate on why Britain had rejected Churchill and a Conservative government after the war or whether he might get back into power in the general election that was expected to take place later in the year. At this early stage in my career I had no thoughts of joining the BBC. Anyway, jobs there seemed to be decreasing rather than increasing, because in January 1951 the Corporation announced that it was reducing its team of radio news readers from 19 to eight 'so as to have consistency of pronunciation and performance'. None of the eight had a regional accent and there were no women among them. 'People do not like momentous events such as war and disaster to be read by a female voice,' said a BBC spokesman.

My interview with Hoddy was successful – 'Now, we are offering £2.5s a week. Could you possibly start on Monday?' Such was the simple format of job interviews in the 1950s – well, mine at least! Apart from my two years' National Service – served not in Korea, thank God, but at various 'cushy' RAF stations around the United Kingdom – I spent the whole of the Fifties and the first few years of the Sixties working as a newspaper reporter and fledgling broadcaster in my home county, recording week by week significant and mundane events that were to affect our way of life and occasionally change the face of Hertfordshire for good.

Most vivid are my memories of the protests. First, those from the indigenous population as thousands of acres of farmland began to disappear under the concrete, bricks and tarmac of three new towns and several London overspill estates – resulting in misery for some but happiness and a better way of life for many more. Then, protests from the new town residents themselves, as they complained about the lack of social and welfare facilities and dangers to pedestrians and cyclists caused by incomplete road schemes.

Elsewhere there were campaigns for bypasses as pretty village streets, like those of Markyate and Redbourn on the old A5 Watling Street, began to clog up with heavy traffic. When work began on the M1 motorway, cutting a swath across farmland on the western side of the county, another storm of complaints blew up over the convoys of lorries thundering along to deliver the millions of tons of gravel needed for the motorway's construction.

At school, those of us busy swotting for the 11-plus or the old Oxford School Certificate had no idea of the enormous challenge being tackled by the county's education officer, John Newsom, at that time. With so many new communities springing up, the demand for more schools presented the County Council with what was probably the biggest challenge in its history. In the 20 years up to 1951, Hertfordshire's population had doubled; the school-leaving age had been raised and then there had been a post-war 'baby boom'. It was estimated that, for primary education alone, the county would need 175 new schools by 1960! Faced with these extreme demands, Newsom's department pooled its resources with those of the county architect Charles Aslin and together they came up with a school-building programme that was later acknowledged as 'a brilliant example of local initiative'. Indeed, some of the designs produced for the Hertfordshire programme were later adopted by other education authorities across Britain.

Having lived nearly all my life in this county, *The Way We Were* has inevitably turned into something of a personal odyssey, although I am delighted to say that many others have elected to make the journey with me. My appeal in the local papers produced a wonderful selection of memories from fellow 'Hertfordshire Hedgehogs', who were either born here or came during the war and stayed on to find jobs, to marry and set up home. Of all the recollections, the most popular have been those remembering the way we spent our leisure time. Parents had fewer worries for our safety as they shooed us out of the house to play in the woods and fields with strict instructions not to return home until lunch or teatime. We went on long cycle rides, we built ourselves 'soapbox' trolleys and secret camps and indulged in the most wonderful games of imagination. Then we started to grow up. On Saturday nights, with television still in its infancy, the cinema reigned supreme. For 3s (15p), a bloke could treat his girlfriend to the intimate luxury of a seat in the back row of the circle – with the prospect of a spot of snogging before the main feature began. Sex remained a mystery much longer in those days.

This was a time before the permissive age; when children were taught by well-tried methods that rarely changed; when emphasis was placed upon their future responsibilities in life rather than their rights – a more austere world but one full of optimism, as we gradually shook off the effects of the war and began to feel the warmth of the economic recovery and prosperity that eventually took us into the self-indulgent Sixties.

Yet – as some contributors make only too clear – the war and the price of victory were to have a profound effect on family life until well into the 1950s. Many found it hard to separate memories of that decade from those of the dark years that had gone before. For this reason, the book begins with a selection of experiences from the 1940s which may help younger readers to understand just how much World War II affected the attitudes and life-styles of Hertfordshire people as they entered the second half of the 20th century.

Richard Whitmore
Hitchin

ACKNOWLEDGEMENTS

As well as the many people who have contributed memories to this book, the author would also like to thank the following for their kind help and the loan of photographs:

Baldock Museum & Local History Group with Edith Page and Norah Penfold; Philip J. Birtles and the de Havilland Aircraft Museum Trust; Dacorum Borough Council and Dacorum Museum; Express Newspapers Ltd; the *Hertfordshire Advertiser* newspaper; *Hertfordshire Countryside* magazine; Hitchin Museum; Terence F. Knight; Pirton Local History Group; and Stevenage Museum.

CHAPTER ONE
'WE ARE NOW AT WAR WITH GERMANY'

Bridget West was eight years old and living in Watford on that September day in 1939 when Prime Minister Neville Chamberlain made his fateful announcement. 'I remember the first air raid siren that Sunday morning following his words on the radio: *We are now at war with Germany*,' she writes. 'As we all sat on the cellar steps waiting for the planes to come, my mother ran to the garden gate to peer up at the sky. A newly appointed ARP warden, complete with arm band, rushed to remonstrate with her and send her indoors, but she told him not to be so silly and almost immediately the all-clear went and the alert was all over.'

Meanwhile, across the town at Garston, Jean Harding had just celebrated her ninth birthday and was at her grandmother's house, showing her the presents she had received. 'After hearing the announcement, Gran became quite agitated and said I must go home at once. So I set off from Chester Road to cycle back home to Gammons Lane. When the siren went off shopkeepers were standing outside their shops all the way along St Albans Road. They called out to me to shelter, but I continued on my way and when I reached home my Mum and Dad were standing at the gate waiting for me.'

That siren had actually been one of many false alarms across the country; the aircraft that had caused all the fuss had turned out to be a friendly one.

Gwen Tomlin's earliest war memory is of her mother's first move whenever the air raid siren sounded: 'To darken the room, she would grab a pair of

my navy blue school knickers and stretch them over the lampshade!' she told me.

Albert Vaughan, who later joined the Home Guard, reckons that he was the first casualty of the war. 'I suppose that these days it would be referred to as friendly fire,' he says. 'War was declared at 11 am. By 11.05 am I had joined the volunteers who went with picks and shovels to dig trenches in front of the Kayser Bondor factory where we worked. It was chaotic because no one was in charge. As I was shovelling soil, the man next to me took a swing with his pick and accidentally struck me an almighty blow on the head. So my first day of the war was spent in a doctor's surgery having a badly gashed scalp stitched up!'

Those living in the south of the county were so close to London that the Luftwaffe's Blitz was literally on their doorstep. Bridget West, now living at Northchurch Common, near Berkhamsted, writes: 'In Watford, as the war progressed we would stand at the kitchen door and watch the night skies. The beams of searchlights criss-crossed the sky night after night and – as the battle of the skies developed – we watched the dogfights of the planes and the bursts of fire and explosions over London.

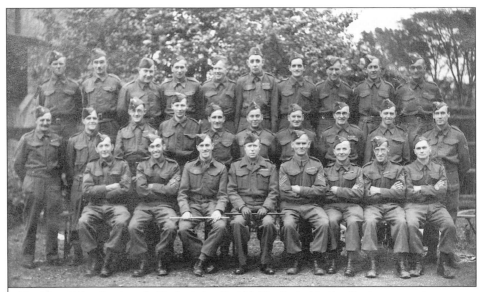

The Home Guard unit at Baldock during the 1940s. Seated in the front row, third from the left, is Lt Albert Vaughan.

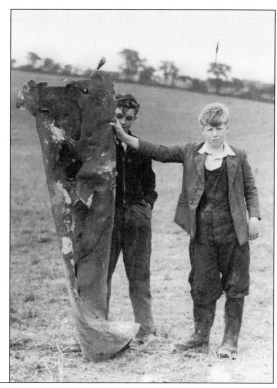

Pirton village boys Ken and Sam Burton with a piece of a doodlebug that landed in Pirton in 1944. Ken, who tells the story in this chapter, is in the background.

'We were worried on the nights when there were bad raids, particularly when bombs or power cuts delayed the trains to Watford upon which my relations travelled. Sometimes passengers had to get out and walk along the track to the next station, sometimes through a tunnel. My uncle was stone deaf. How he managed in the pitch black I shall never know. On occasions, when the adults went to the cinema round the corner, it was so dark when they came out that they had to feel their way home along the wall! We all survived but I remember a row of terraced houses in North Watford that were used to re-house bombed-out Londoners. One night the row was demolished by a flying bomb, a doodlebug, and the people were killed. There were some who seemed to be marked out for tragedy.'

The Watford incident that Bridget remembers occurred in July 1944 and was the worst of the county's 154 flying bomb attacks: 38 people were killed that day and 64 injured. Fortunately, most of the other doodlebugs and V2 rockets fell in rural areas, where the population was less dense. Two came down in

the village of Pirton, causing serious damage to several buildings, but, miraculously, no loss of life. Members of the National Fire Service found one lady who, although badly cut about the head, was still sitting in bed smoking a cigarette. The following morning the Bucket family ventured out to the little stable at the back of their cottage to see if their horse was all right. The building was still standing but the roof was damaged. As they led the horse out, the building collapsed completely. The patient beast had been standing all night bearing the weight of the main beam upon its back!

Ken Burton was an 11-year-old Army Cadet: 'We were assembled to run errands for the Home Guard, who were busy pulling people out of the ruins and covering the damaged roofs with tarpaulin to keep out the rain,' he writes. 'The Women's Institute and WVS swung into action and the village hall was soon full of people cooking food and finding beds for those who could not go home.' (Indeed, damage to some cottages was so bad that two families had to spend a year living in a room in the hall.) Ken remembers: 'Although no one was killed or seriously injured, quite a few were badly shaken. I thought it was very exciting. The next few days saw the whole village in a flurry of work repairing the damage, and my Uncle Alf, who was the village builder, was hardly at home.'

Joan Cook, whose family – the Daniels – had moved from London to Hemel Hempstead shortly after the outbreak of war, remembers her mother providing accommodation for those who had had their own homes destroyed. 'When other members of our family lost their homes during the London Blitz they came to live with us. We only had a small semi but Mum took them all in and we never heard her complain once.' Her sister, Gwen Tomlin, added: 'At one point there were never less than 10 of us in the house. When others arrived, Mum found them rooms further down the street.'

However, there were also some benefits in being so close to London. American B-17 bombers were based at Bovingdon, just two miles south of Hemel Hempstead, throughout the autumn of 1942 and Bovingdon became the drop-in centre for numerous VIPs. Among these were Hollywood stars Bob Hope and Bing Crosby, on their trips to entertain the troops, and Clark Gable, who flew on several missions with the American bomber crews. The airfield was also host to the most famous B-17 "Flying Fortress" of all time, the *Memphis Belle*. Her skipper, Captain Robert K. Morgan, made Bovingdon

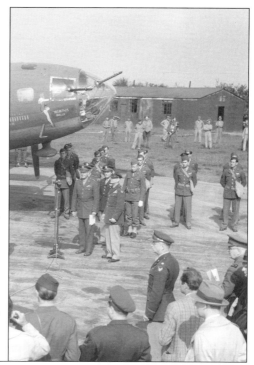

A ceremonial send-off from Bovingdon airfield for Captain Robert K. Morgan and his crew of the now-legendary B-17 bomber Memphis Belle *before they left for a morale-boosting trip of the United States in June 1943.*

his official departure point when he and his crew took the aircraft over to the United States on a morale-boosting tour to encourage Americans to buy war bonds. Since then, *Memphis Belle* has featured in two films about the American Eighth Air Force's wartime operations from this country.

It's not surprising that aviation stories feature strongly in the memories of Hertfordshire folk – the county produced two of the most famous aircraft of the war years. Peter Crolla, in 1940 an apprentice draughtsman with the de Havilland aircraft company at Hatfield, was selected to join the small design team working on a top-secret development project that was to produce one of the great triumphs of British aviation history – the Mosquito. This twin-engine, high-speed bomber was made of wood, yet could fly faster than any fighter of that time. It was also capable of carrying four 500-pound bombs over a range of 1,500 miles. Ironically, the Air Ministry had turned down the original project when it was put forward by Sir Geoffrey de Havilland, mainly because the aircraft was not made of metal. It was only because Sir Geoffrey and his chief engineer, C.C. Walker, decided to 'go it alone' that the first

prototype of this versatile aircraft was built. The Mosquito team was transferred from Hatfield to Salisbury Hall, an old mansion situated a few miles south at London Colney.

'Those of us selected to work on the project considered ourselves the elite of the de Havilland work force,' Peter recalled. 'One of my most memorable jobs was helping with the design of the armaments for the Mark VI Mosquito, a fighter-bomber with four cannon and four machine guns mounted in the nose. There was a wonderful spirit among the team and we all looked forward to the moment when the pilots came back to show off the latest version to its designers by "shooting up" Salisbury Hall. They sometimes flew so low over the building that lumps of plaster fell out of the ceiling!'

By the end of the war, nearly 7,000 Mosquitos had been built. Of this lethal flying machine, the chief of the German Luftwaffe, Field Marshal Hermann Goering, once said: 'I turn green with envy when I see the Mosquito!'

Meanwhile, at the Radlett aircraft factory of Sir Frederick Handley Page – just down the road from Hatfield – the Halifax bomber was being rolled off the assembly lines at almost the same rate as the Mosquito. Another extremely versatile machine, the Halifax was the first four-engined bomber to be used in raids on Germany, in March 1941, and it was used by Coastal Command for reconnaissance and anti-submarine patrols. At its peak of production, the

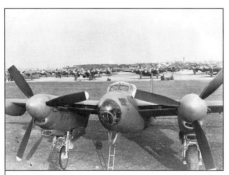 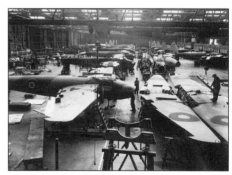

'Fastest aeroplane in operation in the world today – the de Havilland Mosquito is built almost entirely of wood. Thousands of skilled wood workers, some unemployed when war came, are now working on Mosquito production. The plane is powered by two Rolls Royce Merlin engines and is in use as a long-range fighter, as a heavily-armed fighter-bomber and a night intruder. Already air crews have named it "Flying Furniture".' From a 1940s' Ministry of Information press release.

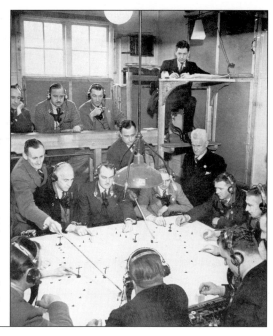

A view of the very basic equipment used at the first Group 17 Royal Observer Corps control centre, when they were 'billeted' in the GPO headquarters while their HQ at Cassiobury Drive was being built.

Halifax project involved 50,000 workers at 45 sites around the country. The bomber remained in service until 1947.

In those days radar was still in its infancy, so the Royal Observer Corps played a vital role in Britain's Air Defence system. The headquarters of Group 17 was in Cassiobury Drive, Watford. Here, the control room team monitored reports from small observation posts dotted across Hertfordshire. Day and night, seven days a week, these teams spent the war scanning the skies and reporting aircraft movements to the Watford control room. Pat Thorne, son of a local farmer, was only 16 when recruited to 'Able One' post at Offley.

'Apart from having to master the names and silhouettes of dozens of enemy and allied aircraft, I also had to learn how to operate a gadget known as the Micklethwait height corrector,' Pat said. 'This instrument stood on a circular gridded map in the centre of the observation platform, enabling the observers to move round 360 degrees as they plotted the courses of passing aircraft and relayed details to the Watford control room.

'Because we had to be able to hear the sound of approaching aircraft, we could not be under cover, which was all right in fine weather but very

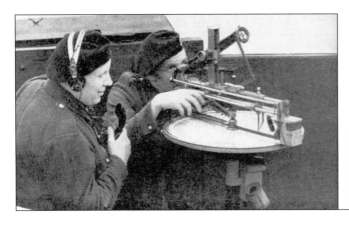

The instrument used by Royal Observer Corps look-out posts to determine the height and speed of approaching aircraft.

uncomfortable in rain or snow. We had a sort of cubbyhole where we took turns to shelter, one crouching over a tiny tortoise stove, while the other stood in the rain, listening out.' Even after a spell of night duty, Pat still had a day's work ahead of him on his father's farm. 'One day, I was ploughing up a field of stubble after three nights on duty and I just fell asleep at the wheel. The crawler tractor and plough went straight through the hedge at the end of the field, and when I woke up I was in the lane. I kept very quiet about it, and when my father found this huge hole in the hedge later on I told him it had probably been made by gipsies!'

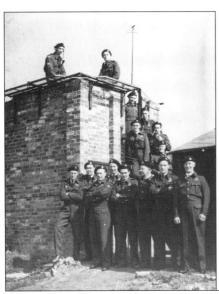

Pat – who now lives in Shillington – says their work was also valuable in helping damaged allied aircraft to find their way back to base. 'Some of our boys would come limping home with their navigation instruments shot up and no idea where they were. We were able to

A strictly unofficial picture of the Royal Observer Corps crew at 'Able One' post at Great Offley, taken when photographing military installations – a rather serious offence! A young Pat Thorne is standing in the centre of the front row next to my father who is second from the left, arms folded.

pass their position to the RAF, via Watford, so that they could get the nearest airfield to guide them home.'

As the war progressed, people on the ground were almost as much at risk from friendly aircraft as they were from enemy action. The American Air Force's insistence on close formation flying resulted in more than 100 mid-air collisions, often when the B-17s were setting out on their missions fully loaded with bombs. Near the village of Graveley two B-17s collided and blew up over Tilekiln Farm. As well as 14 American crewmen, a woman and child were killed by the falling wreckage. Just 600 feet above Ashwell, a Wellington bomber and a Junkers 88 collided in mid-air and exploded. Both crews were killed but, amazingly, there were no civilian casualties – even though wreckage fell into several back gardens and the tail of the Ju88 came down in the High Street! Many more flying accidents occurred after Bomber Command stepped up its pilot training programme by opening flying schools at Steeple Morden and Bassingbourne. In one month, as the young pilots practised their 'circuits and bumps', no fewer than 20 Wellington aircraft came to grief in the area, some with fatal results.

One of my favourite stories from Hertfordshire's war was revealed in 1959 by Eric Hardy, in an article for *Hertfordshire Countryside* magazine. Eric spent most of his war service on 'flying duties' of a rather different kind. As a Fellow of the Zoological Society, he was one of a group of ornithologists brought together by the Army Signals Unit to form what became known as the Pigeon Breeding and Training Company, which was based at Gosmore, near Hitchin. 'We had a dozen fixed breeding lofts and nine mobile trailer lofts, breeding up to 270 young pigeons, or squeakers, a month in order to provide 180 trained service pigeons and maintain a reserve of 360 trained birds,' Eric wrote. Villagers assumed that the birds were being trained to fly messages between military bases in Britain and abroad, which indeed was true. However, by 1943, Gosmore had become the centre for a secret operation that involved training pigeons to bring back messages from our agents working in occupied Europe.

After the birds had been taught to fly home carrying a red plastic message tube clipped to a leg, the best and the strongest were taken to London, where they learned to return to a special loft on the roof of the War Office Intelligence in Piccadilly. Then, sealed in special containers, the birds were parachuted into

occupied territory by the RAF and collected by the agents, who later released them to fly back to London with information about enemy troop movements. 'These birds were operating along with the Intelligence Corps, bringing into the War Office the sketch-maps of the German V-bomb and rocket sites and other vital information from the Allies' secret agents,' Eric Hardy said. 'Many RAF raids were based on the secret information these birds brought back. Unlike wireless, the flying pigeon could not be listened-in to and, more important, it could also carry maps and diagrams.'

The collection of wartime memories recorded in this chapter tells but a fraction of the full story of the part Hertfordshire people played in the war. A fraction of the suffering and sacrifices made. Yet, there is sufficient to create a picture of those half-dozen defiant years which – but for the outcome of the Battle of Britain – could have turned out so differently. Just how differently was a fear at the back of every adult's mind.

Throughout the war my father owned a revolver and six rounds of ammunition, which I had always assumed had been issued to him when he joined the Royal Observer Corps. I came across them quite by chance one day, when I was ferreting about in places where I shouldn't have been.

Many years later my father shocked me by telling me that one of those six bullets been intended for me. He had, in fact, bought the weapon privately with the intention of killing his family if the Nazis conquered Britain. He added: 'We knew all about them, you know. The selective breeding. The slave labour. Experiments and executions in the death camps. I couldn't have let them take you away to that.'

He'd even worked out the order in which we were to be dispatched. First me, then my baby brother, then my mother. That would have left three rounds. 'A couple for the first two buggers through the front door; the last one for myself.'

'In 1940 you were far too young to understand what it was like,' he said. 'They were only 25 miles away and bombing our cities to pieces. You cannot begin to imagine how we felt.' In a sudden outburst, as though ticking-off his teenage son once again, he almost shouted: 'And don't ever forget, boy, how we all just sat back and let that bloody little tyrant come to power. A few short years. That's all it took. Don't ever forget that, boy. Don't ever forget.' We never spoke of it again.

CHAPTER TWO
New Lives – New Towns

For some children of the 1940s, peacetime began with having to make a major adjustment to their domestic lives. Little boys and girls who were either babies or unborn when their fathers went off to war suddenly had to get used to having a total stranger about the house. Malcolm Moulding of Hertford was one such child. Born in 1938 his first memory of his father is of the day he came home in 1945. 'Dad was called up in 1939, when I was just over a year old,' he writes. 'He joined the Royal Artillery and spent almost the entire war on the guns, first in North Africa, then Italy and Greece, and did not come home until it was all over. I can remember waiting with my mother in the garden of our council house in Mount Road. She had put up a big sign in red, white and blue that read *Welcome Home Dad* and spent some time telling me how I should run forward and greet him when he arrived.'

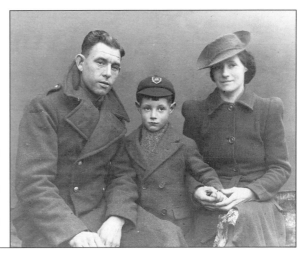

Malcolm Moulding of Hertford with his parents in 1945. The family portrait was taken to celebrate his father's safe return. It was also the first time all three had been pictured together.

However, once the euphoria over Dad's safe return had died down, young Malcolm found himself in for a bit of a shock. 'I suppose Dad was trying to impose his authority on the household after all those years away, but he became very strict and seemed anxious to ensure that I didn't grow up a sissy. One of my most vivid memories is when he stopped me from taking a hot-water bottle to bed on cold nights. He said I'd been a Mummy's boy for six years and it was time I had a bit of discipline. Many of my friends who'd also been brought up by their mothers through the war had similar tales to tell.'

As a prisoner of the Japanese, Janet Grant's father, Edgar Newman, worked on the notorious Burma-Siam death railway. She was only two when he went off to war and therefore too young to appreciate the ordeal he had been through when he finally returned to their home in Hitchin in 1945. 'We were told he would be home in October, about the time of my seventh birthday,' Janet said. 'My main memory is one of feeling annoyed when my mother told me that – because of rationing – I might have to give up my birthday cake so that she could make one to celebrate father's return ...'

Brenda Ward of Royston remembers feeling intensely jealous of her father on his return when she was eleven. 'My mother had brought me up on her own and still found time to work in a munitions factory at Letchworth. Being an only child, I had grown very close to her, so for a while I hated my Dad when I saw the affection my mother was showing him. Whenever they went off out for the evening it really hurt.'

Apart from adjusting family relationships, Britons also had the enormous task of rebuilding the economy and providing new homes for the population. In fact, the period of recovery lasted longer than the war itself and many people

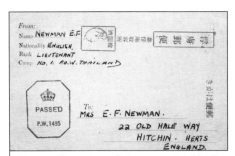
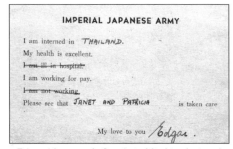

This card was the only letter received by Lieutenant Edgar Newman's family in Hitchin during the years that he was a prisoner of war of the Japanese in Thailand. Both sides are shown.

were still 'feeling the pinch' well into the 1950s; this despite the fact that the government had launched elaborate plans to restore our battered country well before the war ended. One scheme in particular was to have a profound effect on Hertfordshire and its people. In December 1944, details were released of Sir Patrick Abercrombie's master plan for the future of Greater London. It included the proposal to move a million people out of the bomb-damaged capital to eight 'satellite' new towns, of which three were to be built in our county. The first was at Stevenage, followed by others at Hemel Hempstead and Hatfield. There were also plans for overspill estates in a number of other towns.

The scheme had many opponents, and when the Labour Government of Clement Attlee endorsed Professor Abercrombie's proposals with the New Towns Act of 1946 their worst fears were confirmed. The Minister for Town and Country Planning, Lewis Silkin, told the House of Commons that an immediate start would be made at Stevenage with the acquisition of 6,000 acres of farmland to the south of the town. Don Hills, then a young reporter on the *Hertfordshire Express,* well remembers the outcry that followed: 'To local farmers, landowners, businessmen and property owners Silkin's announcement was like a red rag to a bull,' he writes. 'The chosen area contained over 20 farms and would affect 80 others. Three of the town's residential roads were earmarked to be bulldozed. Those affected viewed the threat with shock, horror and outrage. The Stevenage Residents' Protection Association was formed, and when Mr Silkin decided to visit people living in the threatened areas he found posters proclaiming *"Silkin Go Home"* and other similar slogans lining his route through the town.

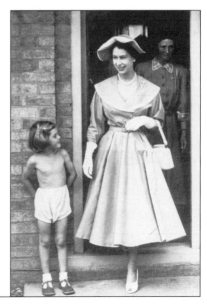

In July 1952, one of The Queen's first engagements after her accession was to visit the Adeyfield district of Hemel Hempstead to lay a foundation stone for St Barnabas Church. She also called on the new town's first official tenants, the Adams family, on what was clearly a very warm day!

21

'That evening Mr Silkin went to the town hall to address a public meeting arranged by the local council. He found the hall packed to overflowing and the road outside blocked by the hundreds who had been unable to get in. The boos and catcalls that had greeted him continued right through his speech. Frustrated by the interruptions he finally shouted in anger: "It is no good you jeering – it is going to be done!" The meeting over, the Minister discovered that someone had managed to let down the tyres of his chauffeur-driven car and pour sand into the petrol tank.'

From his stately home, Knebworth House, which sits on rising land to the south of Stevenage, the then Governor of the Bank of England, Mr Cameron Cobbold (later Lord Cobbold), had almost a bird's eye view of the new town's development. His elder son, David, the present Lord Cobbold, was a schoolboy at the time. 'I had a bedroom in the tower of Knebworth House

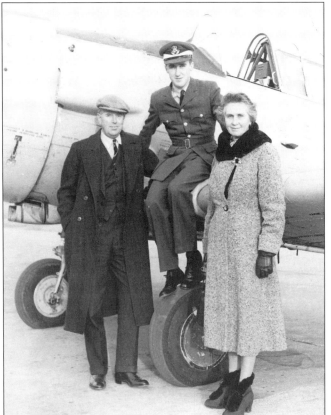

which had wonderful views straight down our tree-lined avenue and across the farmland on which they were building,' he told me. 'Each time I came home from Eton for the holidays I would go up to my room and find that another area

Pilot Officer David Cobbold, aged 19, of Knebworth House, pictured in 1956 during his National Service days at Moose Jaw in Canada, where he learned to fly on Harvard trainers. He is with his parents, Mr Cameron and Lady Hermione Cobbold.

of land had disappeared beneath new roads and housing estates. And so it went on year after year. When I went off to do my National Service in the RAF, I'd come home on leave to find more incredible changes in the landscape.'

As the years went by, Lord Cobbold became closely involved with voluntary work to provide facilities for the pioneer residents. As a member of Stevenage Youth Trust, he helped to found Bowes Lyon House, a centre for young people that still flourishes today.

With nine out of ten homes in the Greater London area damaged or destroyed during the war, accommodation was at a premium for many years afterwards. To the young couples who were faced with having to spend their first married years in lodgings or sharing a house with relatives, the opportunity to head for the countryside and breathe life into the new town of Stevenage seemed almost heaven-sent. But starting life in a new town had its drawbacks, as Don Hills recalls: 'In those early days all the newcomers found themselves in the same boat. Living on building sites with little in the way of amenities. However, they quickly formed themselves into local community associations, which were affiliated to an umbrella Residents' Federation, so they could speak with one voice to the Development Corporation and the other agencies from whom they were demanding the missing amenities – surgeries, social centres,

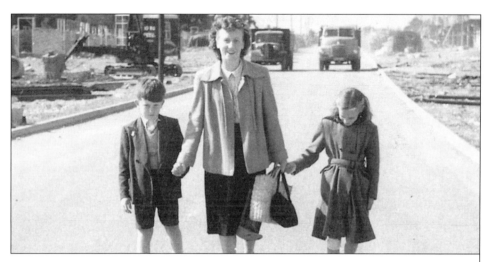

Pioneer residents. Mrs Florence Gresley taking her children to school in Stevenage New Town in 1954.

23

telephones, postboxes and so on. I found the pioneer new town residents totally different from the rather conservative folk of old Stevenage. I would knock on a door and be invited in and offered a cup of tea, almost before I had had time to introduce myself. Until then, I had rarely met such friendly people.'

For many young couples elsewhere in the county, the post-war housing shortage had meant beginning married life in far more basic conditions. Bob Norris, now of Rickmansworth, was one of a small community who for a while lived in improvised homes in the village of Bedmond, near Abbots Langley. He writes: 'Fortunately, my wife Mary and I had bought a plot of land in 1939, so with the agreement of the council we erected a simple home on it. This consisted of a large shed that had once been an artist's studio put together with a poultry house. We had a gas supply and water but no electricity or main drainage. In those days, the village still had cottages where the council workers collected night soil from the outside toilets.

'For a while we had no furniture. A few planks supported by surplus bricks made a table. Orange boxes, which were then quite substantial wooden crates, made cupboards and a second-hand stove burned all night to keep us warm. There were no washing machines and you would be lucky to have a mangle or wringer to deal with the two dozen nappies and the rest of the weekly wash. The water had to be heated on the gas stove – a fairly hazardous operation!' Bob says that because milk, cheese and butter were still rationed, some of the families decided to acquire a goat, which they tethered on the roadside verge and milked each evening when they returned from work. 'Food rationing remained in force for several years, but concentrated orange juice, rose-hip syrup and cod liver oil were all free for young children, and we had a home help who came over from Hemel Hempstead, which was a great boon to Mary – who had three babies to manage and feed.'

Ken Burton of Hitchin and his wife Edna bought a caravan shell for £120: '... my Uncle Alf fitted it out for us as a wedding present,' said Ken. 'When we got back off honeymoon Edna went to wash her hands in the sink and when she pulled the plug out the water poured out over her feet. Unfortunately, no one had fitted the pipe that carried the water out to the pail under the van!' Other problems that they had to contend with were the lack of ventilation causing condensation, which, when the weather got very cold, froze and stuck

their bedclothes to the wall, and a build-up of cigarette smoke and fumes from the Valor heater, making breathing difficult. 'But when you are just married and love each other you are quite happy to put up with a few inconveniences to have a place of your own,' says Ken.

One of Watford's up-and-coming areas at that time was a housing development on the Woodside estate to the north of the town, near Leavesden. Among the first to be offered a council house there were Jim and Bay West, who came originally from Gravesend. Their second daughter Ann, now Mrs Ann Waine, of Chipperfield, was born in 1950, shortly after the family moved into number 113 Horseshoe Lane. As with the new towns, it was some time before these large estates had their own shopping precincts. Ann writes, 'So Mum had to rely on the travelling grocer's van – a converted bus – which used to call once or twice a week. She also used the Co-op milkman and baker. I can still see the baker calling at our house with his foot on the doorstep and balancing his wooden tray of bread and cakes on his knee while my mother made her choice.

'Sometimes we would catch the bus up to Seakins, the nearest grocery shop, which stood at the corner of College Road and High Road in Leavesden. The bus fare was about a penny halfpenny (just over half a new penny). It was a really old-fashioned corner shop and I used to watch, fascinated, as Don Seakins carved the ham on his slicing machine. If I was good, Mum would let me choose a cake from the window. Then she would leave her shopping bag and the little red book containing her order and Don Seakins would deliver it to the house filled with her groceries at the end of the week. I also remember the rag-and-bone man, who was a regular visitor to the lane, and another caller who sold toffee apples and other things. On Saturdays Mum might take us into Watford town shopping. This was in the days when there was no one-way system and traffic flowed freely up and down Watford High Street. Mum always paid a visit to the market, which was situated behind Cawdells in those days and was always *very* windy. We would buy shrimps, whelks or winkles, whichever took her fancy, and these would contribute to our Saturday night supper.'

This chapter concludes with a reminder of how – following the war – the people of Hertfordshire opened their doors to Europeans who had lived for years under Nazi tyranny. Bridget West sent me a treasured snapshot of Lotte

Lotte Stobbe (left) and her friend Beppie after their six-month stay in Watford in 1945, when families in the town entertained a group of Dutch children recovering from traumas and malnutrition under the German occupation.

Stobbe who came to Watford in 1945 'to be fattened up', as she puts it. Lotte was among a group of children brought to Hertfordshire for a six-month holiday to recover from the traumas and severe malnutrition they had suffered living under the 'Bosch', as they called the Nazi occupation forces. Said Bridget: 'A remarkable Watford lady called Mrs Freeman organised the whole thing. We had to go to the centre in Clarendon Road to pick up Lotte. She was very silent and withdrawn for a while. She could climb the stairs only very slowly, having to rest with both feet on each step before she could move on. Then we found out that parts of her body were covered with terrible boils but once they had been treated and cleared up she became a different girl. She was full of beans, began to put on weight and was great fun. … When the children went back to Holland they took all sorts of unlikely presents for their families. Not luxury items but practical things that their parents could not buy in Holland. Lotte filled her suitcase with things like reels of cotton, shoe polish and laces. The boys went out and bought inner tubes for their bikes.'

This story of a Polish schoolboy named Waclaw Jaworski recalls the courage and determination of other families who fled from their homelands, or were driven from them by tyranny, and arrived in this country with their worldly possessions in a couple of suitcases – families who then rebuilt their lives and went on to become valued members of the Hertfordshire community. 'Johnny' Jaworski – as he is now known – was five when Poland was overrun and partitioned by Germany and Russia. His father, a schools inspector, was arrested by the Russians on a trumped up charge of 'anti-communist activities'

and sentenced to 10 years' hard labour. Johnny and his mother were transported to Siberia to live with a Russian peasant family. After Hitler's invasion of Russia, Mr Jaworski was suddenly released and miraculously re-united with his family.

With no possibility of going back to Poland, and classed as 'undesirables' by the Russians, the family teamed up with about 50 other Polish exiles in a similar predicament and plotted an escape to Odessa on the Black Sea. Their hair-raising exodus from Russia involved bribing a railway official to supply them with a large cattle truck, which was hastily fitted out with wooden bunks. With the families hiding inside, the truck was then attached to a southbound train. 'After that came a nightmare journey of hundreds of miles, which lasted 32 days until we reached safety,' Johnny told me. '... Two of the older people died during the journey and the adults had to make the difficult decision to throw the bodies out of the truck at night so that we would not be discovered. I was seven years old at the time.'

Having arrived safely in Odessa, the family made their way via various refugee camps to India, from where they eventually obtained a passage to England. Young Johnny arrived in the autumn of 1947, on his twelfth birthday. He spoke no English and claims to have learned the language from reading *Hotspur* and *Rover* comics. 'I had never seen a comic before,' he recalled, 'but there was this lad Robin Packham in my class who got comics every week and used to lend them to me. I couldn't understand what they said, so I used to plead with him to go through the stories and explain them to me. In effect, he taught me English. I would love to meet him again and thank him because I must have been an absolute pest.

'... I came to Hertfordshire in 1950 when my father was appointed headmaster of a school for Polish orphans that had been opened at Shephalbury Manor, Stevenage. My first memories of Stevenage are green fields and country lanes – and apples. Having grown up in displaced persons, camps in the Middle East and India, I had never tasted an apple before and I thought they were marvellous, although I had several uncomfortable experiences before I realised that there were two types – eaters and cookers!'

While at Alleynes Grammar School, Johnny Jaworski decided to make medicine his career and he qualified as a doctor in 1959. A year later he married Diana Gale and it was in Letchworth that the couple chose to settle

down and raise their family. In 1997 – exactly 50 years after his arrival here as a homeless schoolboy – Dr Jaworski retired, having served his community as a family doctor for more than 30 years.

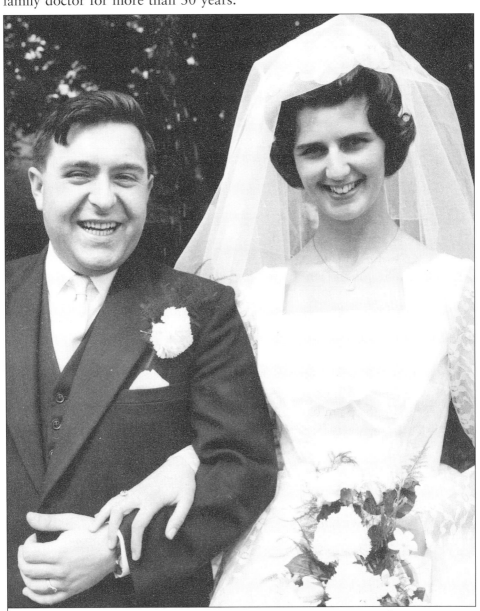

Dr Waclaw (Johnny) Jaworski and his bride, Diana, after their marriage in Stevenage in 1960.

CHAPTER THREE
SCHOOL DAYS

M ost of us have vivid memories of mini-traumas experienced during early years at school. My own began at the age of five at the Convent of the Sacred Heart at Hitchin, a girls' school that also catered for a handful of small boys for a few years, until the nuns decided we were more trouble than we were worth. Life there seemed to be dominated by an endless succession of saint's days, Reverend Mother's days and feast days, one or the other of which cropped up almost every week.

Reverend Mother must have breathed a sigh of relief when we boys left. No more would she have to hold internal inquiries to discover which of us had chalked the obscenities 'Bum' and 'Poo Poo' on the convent wall for all to see. After such behaviour it is hardly surprising that corporal punishment should also be among my memories of those years. It was usually administered with a ruler, either on the palm or across the delicate bones on the back of the hand. This latter torment was favoured by an unpleasant woman – a French refugee, not a nun – who spoke no English and so was quite unable to communicate with her young charges. After screaming at us in French had provoked only laughter she resorted to violence, lining us up to receive a series of vicious blows inflicted – not with a ruler – but the wooden handle from a skipping rope. No wonder we had trouble improving our handwriting.

Being left-handed myself, I felt an immediate empathy with the problem of handwriting touched on by Barbara Boxshall of St Albans in her memories of the St Lawrence Primary School at Abbots Langley. 'We still had inkwells and high pairs of wooden desks,' she writes. 'There seemed to be rows and rows of us crammed into each classroom, sitting in lines with elbows sticking out. I am

naturally left-handed, but we were told that this was wrong and so I was forced to learn writing all over again with my right hand. The left-handers didn't argue because we had heard stories that anyone caught trying to write with their left hand might have the desk lid shut on their fingers by the teachers! As a result I still write with my right hand today, even though I do everything else left-handed.'

Janet Grant's first school was a small private kindergarten called St Luke's, in Hitchin.

'I was sent there at the age of five because my mother found out that they taught French and she considered that the ability to speak French was essential for a girl being brought up to become a young lady. Unfortunately, they spent so much time on that subject that when I later transferred to a state primary school – Wilshere Dacre – the staff there discovered that I couldn't read English at all well!'

Ann Waine was born in 1950 and grew up on the new Woodside Estate in Watford. 'When I was almost five I started at Alban Wood infants school. There was a little gang of children from the estate who all went together on the bus – can you imagine children of five doing that now? Apart from the first day, I always walked to school on my own. You were considered a sissy if your mum met you from school. I loved school from day one. Some of the friends I made there 45 years ago are still friends today. When I was seven I changed schools and went to Leavesden Green Primary. It was a long walk in all weathers but we had no car and, anyway, walking to school was an adventure. I had to stay to school dinners, which were abysmal in those days. However, there was no choice. You ... sat there until it was eaten. That often meant sitting and staring at your congealing dinner all afternoon.'

The sisters Gwen Tomlin and Joan Cook, of Hemel Hempstead, went to Nash Mills School during the war and well remember the hasty evacuations to the school shelters whenever the siren sounded. 'But lessons went on even when we were in the shelter,' said Gwen. 'We used to think it a huge joke trying to recite our six times table while wearing a gas mask!' Fortunately, the school was empty when it was damaged during Hemel Hempstead's worst air raid on the night of May 10th 1941. The bombs fell in nearby Belswain's Lane, destroying two houses and killing nine people, including a child.

Jean Harding of Garston recalls: 'At the start of the war I was attending Callowland School and I remember we had to take an emergency rations tin in case we had to stay on at school because of air raids. Mine contained Horlicks and Ovaltine tablets and an individual fruit pie. Whenever the sirens went off, we all had to file from our classrooms and sit along the corridors on the floor. Later, I attended Leggatts Way School. The one abiding memory of my time there was when I was in the third year and every time the siren went we older girls had to rush over to the children's nursery and grab a baby to take to our shelter. As you can imagine, we made a beeline for the most attractive baby to hold until the all-clear sounded!'

Because the nuns of the Sacred Heart Convent had terminated my education earlier than expected, I was still too young to join the preparatory form of Hitchin Boys' Grammar School. However, this being 1942, the fates of war came to my rescue when the staff and 260 boys of Eastbourne Grammar School were evacuated to Hitchin to escape the German bombing raids that were then a daily event along the south coast. With incredible ingenuity the Hitchin school, despite having 360 pupils of its own, managed to accommodate the visitors within its existing buildings in a way that still allowed the two schools to operate independently. The headmaster of Eastbourne, Mr Blackburn, agreed to squeeze me into his preparatory form for a few terms until I was old enough to be transferred. It was kind of him really, considering that I couldn't answer the one question he posed during my short interview. 'How many twopenny-halfpenny postage stamps could I buy for half-a-crown?' he asked. Anyway, I was accepted and can now claim the unique distinction of being the only old boy of Eastbourne Grammar School who has never actually set foot in the place. The answer to the question, by the way, is 12.

In 1944 R.A. Butler's 1944 Education Act was passed, with its 11-plus examination, designed to separate the intellectuals from the artisans. Those who passed went to grammar school; those who failed went to secondary modern or technical school.

The ordeal of sitting the 11-plus features most often among these recollections of school life in the Forties and Fifties. Maxine Elvey of St Albans is still haunted by the arithmetic paper. 'I was getting towards the end of the exam, when there was a question about three farmers who each owned a field of a

The scholarship class at Wilshere-Dacre School, Hitchin, in 1950, pictured with their teachers, Mr J. Martin, Miss K. Hadley and the headmaster Mr R. L. Bryant. Later that year Mr Bryant was quite badly injured when the hall clock fell on his head while he was teaching.

different acreage and we had to work out how many acres they owned altogether. I panicked and put my hand up. "We haven't done area yet," I said. I was told to leave the question and go on to the next one. However, I continued to panic and felt faint. Then I started to cry. I had felt out of my depth with arithmetic before. I still remember the appalling sight of a long division sum filling the whole blackboard when it was first explained to us by our teacher, Mr Reece. Anyway, the invigilator decided I should be taken outside to get some fresh air. The manner of the lady who took me outside was very grave. We walked in a circle around the playground then returned inside and I continued with the exam. The strange thing is that, in my heart of hearts, I realised that the problem was really one of simple addition but the mention of fields and acres had thrown me.'

Maxine believes that it was this incident that resulted in her becoming what was termed 'a borderline case' for grammar school education. As a result, she had to go for a special interview with the headmaster of East Barnet Grammar School. 'I was shaking all through the interview. When he asked me what books I had been reading I told him *Northanger Abbey* by Jane Austen ... because my cousin Barbara had greatly impressed her interviewers when she told them she read Jane Austen. Mr Clayton asked me several questions about the book and I later heard that I had passed the interview.'

Being at a grammar school could have its hazards. Boys from the secondary modern schools – the 'council' schools as my mother called them – would sometimes lie in wait for us, to leap out and shout 'dirty dogs, grammar gogs' or ambush us with stones and lumps of earth.

According to Bridget West, the young ladies of Watford Grammar School for Girls were known as 'grammar grubs'. She and her sister Margaret were at the school together and, like everyone else, had to go to remarkable lengths to preserve clothes. 'Because of shortages, uniforms became rather well worn,' she says. 'So when the sleeves of our blouses became frayed, the frayed piece was cut off and the sleeve re-stitched. As a result, they sometimes became so short that we could only wear them under a pullover. When woollens became worn out, it was not unusual to unravel them and use the wool to knit something else. At school in the summer we were allowed to wear sandals without socks. However, we could not be seen in the street without gloves! I wonder what my granddaughter would think of having to wear gloves in the summer?' Bridget asks.

'But they were happy, busy days. Founder's Day came round once a year and the entire school went in crocodile to the parish church to sing the 'Te Deum' and 'Our fathers by whose servants our house was built of old'. Because it was not possible to get proper panama hats at that time, we had these horrible monstrosities made of what looked like burnt straw. How we hated them! Thankfully, because of wartime shortages, we were eventually allowed to wear berets. But the best bit of Founder's Day was that it was also a half-day and, being in the early part of the summer, we were able to escape to the town swimming baths for our first swim.'

Mrs Susan Hunt, now living in Hertford, grew up in the Rickmansworth and St Albans areas and in 1952 became a weekly boarder at the St Albans High School for Girls. She writes: 'Most of our teachers were elderly spinsters, some of whom had been there during my mother's time at the school. Rationing was still in force, of course, and the food was pretty poor for my first couple of years. I was lucky because – unlike the termly boarders – I had weekends off. My mother used to meet me off the bus in Watford some Friday evenings and my great treat was to be taken to Fuller's Tea Shop in the High Street. It was lovely, with white tablecloths and silver teapots and water jugs – and Fuller's walnut cake! This cake was a dream, a mouth-fulfilling experience of wonder: soft cake with bits of walnut – in two layers with cream between – and the most scrumptious and smooth sugary fondant icing in the world on top and down the side – and you usually got a very big slice! The worst possible moment came when it was "off" and there were only Kunzle cakes – for me, a dreary lacklustre alternative.'

The fact that most of Susan's teachers were 'elderly spinsters' is not that surprising when one remembers that, up to 1944, women teachers were discouraged from marrying. A copy of the prospectus for the Watford Grammar School for Girls, sent by old girl Bridget West, shows there was only one married woman among the 30 teaching staff. All others, from the head mistress, Miss Jean Davidson, to the school secretary, Miss Havelock, were spinsters. It was during the introduction of his 1944 Act that Education Minister R. A. Butler announced that women teachers would in future receive the same pay as men and that the ban on them marrying would be lifted 'because of their great war effort'.

Ken Burton was a couple of years above me at Hitchin Boys' Grammar and, being a farmer's son, he was expected to work on the farm when he arrived home each day.

'I was only 10 years old when I was taught to drive a tractor,' he writes. 'One day I came home from school and had to go straight back into town with a tractor and trailer to collect a load of pig food. Unfortunately, I had forgotten to take off my school cap and blazer and was spotted by two masters. Next

morning at assembly the head-master, T. E. Jones, announced that a boy in school uniform had been seen driving a noisy tractor through the town and would Burton go to his office and explain himself. I told him I was helping with the war effort, as we all had to do our bit, and he let me off.'

Our school then had a disciplinary system under which house points were deducted for bad behaviour. At half-term these were averaged over the number of boys who had lost them. Any boy above that

The author, March 1950.

average was given a week's detention after school hours. In detention we were given 'tots' to do – a euphemistic misnomer if ever I heard one! Tots were vast arithmetical problems that involved having to add up huge sums of money – all without the help of a calculator, of course. Detainees had to get two correct answers before they could go home. One day, a boy opened his copy of the questions and found that an answer book had been left inside. He said nothing to anyone and spent most of the detention furtively copying the answers onto a sheet of paper before slipping the book back on the master's desk. The following week he did a brisk trade selling copies at 1s (5p) a time. After that, detention was more a question of overcoming the boredom.

Up to this point I had survived the system pretty well. My problems came when T. E. Jones decided to introduce a new scheme under which lost house points were to be added up every fortnight instead of every half-term – and any boy who had lost more than five in that fortnight was in trouble. The first time this system was used I knew I'd had a bit of a bad run. Just how bad, I didn't realise until the head read out the list of offenders that day at morning assembly. When he got to my name T.E. Jones' voice tailed off and he looked across at his staff in disbelief.

'Th … .?'

One of them nodded.

'THIRTY EIGHT!'

Ten minutes later I entered the headmaster's study to find him standing beside his table upon which lay three canes of varying thicknesses. I chose the medium-thick cane, hoisted my blazer, leaned over the table and clenched my buttocks.

As corporal punishment is now banned, it may interest present-day pupils to know what it felt like to receive 'six of the best'. To begin with, the memory of a beating remains with you for the rest of your life, which is probably why it rarely had to be administered more than once. The punishment took place in private without witnesses, which somehow made it feel more humiliating, more of an invasion upon the privacy of one's body. The pain was brief but acute, particularly when two of the blows landed on the same spot. The flesh throbbed for a long while afterwards. The skin was slightly broken and the red weals and bruising lasted for a couple of weeks.

Although I have been tempted to dwell on some of the less enlightening moments of my school career, these are far outnumbered by warm memories of the positive events and in particular the respectful rapport that developed between masters and pupils as we progressed through the school. All the teaching staff were immaculately dressed in three-piece suits and smart shirts with starched collars and usually a university or military tie – confident, educated men, the majority of whom commanded great respect and occasionally a little fear from their pupils. Minor misdemeanours were dealt with summarily by a whack round the back of the head or a flying blackboard duster.

Young cricketers who made up Hertford Grammar School's First XI in 1945.
Top row (l-r) Dick Ribbons, Peter Ashton, Austin Nunn, Harry Fulcher, Eric Whalley and
'Bugs' Barton. Seated (l-r) Alan Merriman, Peter Gardner, Peter Ashley (Captain),
Alan Findlay and Roy Glazebrook. Scorer, Neville Pavey. In 1967, when education
authorities came under government pressure to abolish grammar schools,
Hertford Grammar was renamed Richard Hale School, after the City of London
merchant who founded it.

CHAPTER FOUR
OFF TO WORK WE GO

F or most of us leaving school during the 1950s, the thought that we might not be able to find employment never entered our minds. Our main concern – and that of our parents – was to find a job that offered good prospects of promotion and would last for the rest of our working lives. There seemed to be endless prospects with one or other of the successful companies stretching across the county and producing anything from aircraft and missiles to ladies' lingerie.

Watford had become a major centre of the nation's print industry, with companies like Odhams and Sun Printers producing *Woman's Own*, *Illustrated*, *Picture Post* and other popular national magazines. Ann Waine (formerly Ann West) of Chipperfield, whose father and mother decided to move from Gravesend to Watford in 1947, told me they were considered well off because Mr West worked at Sun printers, a fact confirmed by Barbara Boxshall of St Albans, who writes: 'My dad worked at Yeatmans sweet factory in North Watford mixing the sugar. He did not get holiday pay, so mostly could not come with us on our week at Bognor in August. However, if your dad worked 'in the print' at Odhams or Sun Printers, you had made it!'

Malcolm Moulding left Hertford Grammar School in 1954, hoping to become an apprentice in the print industry, at Stephen Austin, publishers of one of the county's oldest newspapers, the *Hertfordshire Mercury*. 'I was interviewed by an under manager who handed me a card that had a paragraph printed on it and told me to read it out loud. On the strength of this performance I was accepted for a five-year apprenticeship.' Three years later Malcolm met his future wife, Mollie Fenton, when she started work in Austin's book-binding

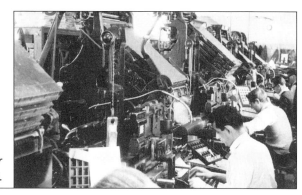

Operators at work on their
Linotype machines.

and print finishing department. Says Mollie: 'I was paid £2.10s a week and
when I arrived home with my first pay packet my mother took half of it for
board and lodging. Can you imagine youngsters these days being prepared to
hand over half their wages to their parents?'

When I joined the *Hertfordshire Express*, my mother seized *more* than half of
my wages, leaving me with just £1 spending money. Yet I cannot recall ever
feeling hard up because of this. The *Express* offices held a grubby but
magnetic appeal; a perfect example of one of those small town English
newspaper offices of the period, hardly changed since the newspaper's launch
a century earlier. The front office was dominated by a smart mahogany
counter and one of those high Victorian desks with inkwells and a decorative
brass rail, at which Eric and Malcolm, from Accounts and Advertising,
perched on stools. In the corner sat Audrey, the telephone operator, with her
headphones and little switchboard with its spaghetti-like jumble of cords and
plugs. The telephone number still had only two digits – Hitchin 93.

Up two flights of stairs to the reporters' room, with its rooftop views across
the ancient town centre. Sweltering hot in the summer, freezing cold in winter.
Next door was a wonderful museum of hot metal printing – the Composing
Room. Here were the racks of wooden trays holding thousands of different
type fonts in individual compartments. The compositors worked with
incredible speed, selecting each letter with tweezers to place it in their
'chase' as they made up each headline for the stories being turned into type at
the far the end of the room on the clattering Linotype machines. Each one of
these had a bar of metal alloy suspended over a tiny gas-fired cauldron in
which the alloy was melted down to be recast into a solid line of type, as the

operator worked his way through the news copy. Then, the focal point, the High Altar of the composing room: running half the length of the room, and presided over by Les the foreman, was the stone, the massive metal-topped table, weighing probably a ton, on which the eight broadsheet pages of the *Express* were made up as the week progressed.

On Thursday evenings the formes (metal frames holding the contents of each page in place) were locked tight and taken down by lift to the old Cossar flat-bed printing press, which sat in her bay already loaded with reels of newsprint. This magnificent machine was one of the last of its kind still in use, most other publishers having already opted for the newer rotary presses by the 1950s. For me and my colleagues, the sight of our old Cossar being nursed gently into motion by her devoted mechanic provided a rewarding climax to the week's work which we never wanted to miss. Just a few copies were run off at first for a final check before the majestic old lady was wound up to full speed to begin her night's work.

Less than a year after joining the *Express*, I had to leave to go off on the obligatory two years' National Service. I applied for the trade of operations clerk with the RAF and spent 18 fascinating months at the Aircraft and

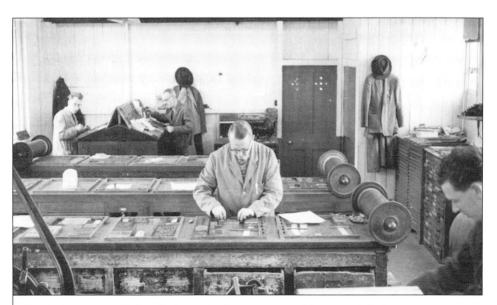

Composing room, with Les Simpson, the foreman, assembling one of the pages for the next edition of the Express.

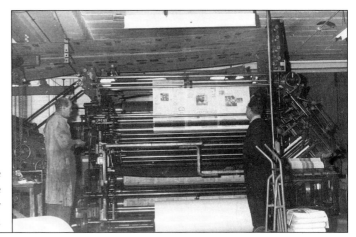

Lining up the
Cosser printing machine
for her Thursday
night run.

Armament Experimental Establishment at Boscombe Down in Wiltshire, where all the country's new flying machines came to be tested: the Hawker Hunter, the Gloucester Javelin and the big V-bombers – the Vickers Valiant, the Avro Vulcan and the Handley Page Victor, built at Radlett.

I found myself working in one of the most modern control towers in the country, taking my turn on long shifts alongside the controller, logging air traffic movements and dealing with visiting aircraft.

Today, my blood runs cold at the thought of the responsibilities I was given: 18 years old, barely six months' service under my belt, there was I helping to direct aircraft into a busy flying circuit; stacking them up in the clouds at 500-feet intervals before bringing them back down one by one to join the downwind leg and onto their final approach. It says a great deal for the National Service system of selection and training, under which raw young men were moulded into a new and disciplined lifestyle which, within a few months, had them trained and ready to play a responsible role in service life.

John Goodwin of Letchworth Garden City touches on this point of responsibility at an early age. After service with the Airborne Division in the Middle East he went to work at the Letchworth company, Irving Air Chute of Great Britain. This company had been founded in 1926 by the American parachute pioneer, Leslie Irvin, who had confounded the scientists by being the first aviator to make a freefall descent with a manually operated chute.

A soldier with one of Irvin's early 'static line' chutes used for troop drops during the war.

By the outbreak of World War II, the air forces of more than 30 countries were using Irvin parachutes but, with peace, demand dropped dramatically, forcing the Letchworth company to reduce its workforce from 500 to about 100. However, two developments prompted by the arrival of jet-propelled aircraft brought a revival to Irvin's fortunes. First, the need for new parachute packs and harnesses for Martin Baker ejector seats and then special chutes – initially for the Lighting fighter – to be deployed as landing brakes when the aircraft touched down. John Goodwin worked on these new projects and is amazed at the responsibility he was given as a young technical assistant in the new research department. 'Having started there more or less as the tea boy and still only a technical assistant, I found myself, surprisingly quickly, organising and

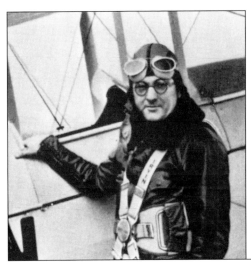

Parachute pioneer Leslie Irvin.

41

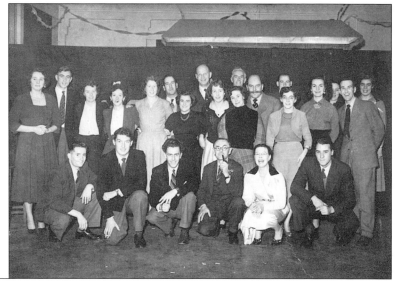

John Goodwin (kneeling, second from the left) at an Irvin Christmas party in 1953.

conducting the actual trials of the equipment on which I was working. I then had to write the reports on the trials. These later formed the basis of the company's submissions to the Ministry of Aviation for approval of the equipment for service use. It seems to me now that I was taking on responsibilities that today would be handled by someone three or four grades higher in the company. But that's what it was like in the Fifties. Everyone was prepared to fly by the seat of their pants in those days.'

John stayed with the company for more than 40 years, ending up on the board as sales director. For services to the parachute industry he was made an MBE in the 1993 Queen's Birthday Honours list.

In 2001, after 75 years in Hertfordshire, the company was taken over and transferred to Wales.

The story of Irvin Air Chute cannot be allowed to pass without mention of the

Logo for the Irvin Caterpillar Club and, below, the Irvin Logo

75 years of Irvin.

Images and information on the 75 years of Irvin Parachutes in Letchworth.

company's exclusive Caterpillar Club, founded by Leslie Irvin in 1922 for fliers whose lives have been saved by an Irvin parachute. Over the past 80 years, membership has grown to more than 100,000. Leslie Irvin chose the caterpillar emblem because the first parachutes upon which aviators depended were made of silk woven from the threads produced by silk moth caterpillars, which also let themselves safely down to earth by the threads that they spin. Today, the club continues to be run at Letchworth by Judy Adams, whose archives contain hundreds of original letters written to Irvin by grateful servicemen.

Liz Colfer modelling an Irvin chute.

Among the club's famous RAF names are Sir Douglas Bader, Group Captain Peter Townsend and John 'Cat's Eyes' Cunningham, the legendary night fighter ace who died recently. In fact, Group Captain Cunningham, who lived at Kinsbourne Green, near Harpenden, qualified for his gold caterpillar just *before* the war. In April 1939, as a test pilot with the de Havilland aircraft company at Hatfield, he and one of his bosses, Geoffrey de Havilland, had to make a quick exit from a Moth Minor aircraft when it failed to respond to recovery action during spinning trials. The two men landed safely near Wheathampstead.

Liz Colfer (formerly Liz Fell) used to be responsible for the final inspection of each chute assembled by her team. 'My 14 years with Irvin were some of the best of my life,' she says. 'It felt as though we were one big family – from the managing director downwards. In fact, five members of my own family have worked there over the years. What brought workers together was a shared sense of responsibility, because it was always at the back of our minds that somebody's life could one day depend on the accuracy of the work we did. As a 20-year-old, I was one of several staff members who volunteered to make a jump with an Irvin chute. It was something I felt I should do.'

During the war another Letchworth company was called in to help the hard-pressed parachute-makers. Spirella – better known for whalebone corsets and other ladies' foundation garments – turned their hands to cutting silk panels for parachutes. With most men away at war, the two companies were staffed almost entirely by women. Brenda Ward of Royston told me that the situation became tricky when the men returned in 1945 expecting to get their jobs back. 'According to my aunt who worked there throughout the war, a lot of the women didn't want to give their jobs up. I suppose they had enjoyed their first taste of Women's Lib and didn't want to lose it,' Brenda said. 'There was quite a to-do that took some time to sort out.'

Kathleen Hardy of London Colney remembers the excitement when her older sister Mary started work at Greens Department Store in St Albans. 'I was still at school but was very interested in the new way of life that Mary was following. She had joined the elite ranks of young ladies who served at this posh outfitters. She worked on the handbag section for a time and had to wear black and white clothes – a uniform really. The staff followed a very strict code. The customers were always addressed as 'madam' – and were always

right. I couldn't wait for her to come home and regale me with tales of the girls she worked with!'

Another company that brought fashion and work to Hertfordshire through the middle years of the 20th century was Kayser Bondor, perhaps most famous for producing the first nylon stockings. Their story began in 1928 when the Fully Fashioned Hosiery Company took over the eye-catching art-deco buildings on the old Great North Road in Baldock that are now occupied by a giant Tesco supermarket. Intended originally as a film studio, the building was soon accommodating vast hosiery production lines that specialised in high quality fully fashioned stockings, in silk and rayon. When local labour was fully absorbed, hosiery workers were recruited from the Midlands and housed in an estate of 180 homes specially built for them just behind

From the Kayser Bondor magazine 1960 – modelling a new range of nylons.

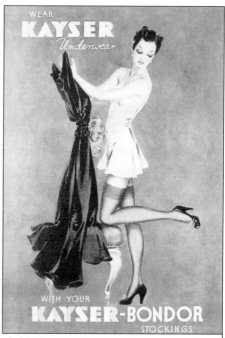

A 1960s advertisement drawing attention to the fact that Kayser Bondor had started manufacturing undies as well as nylons.

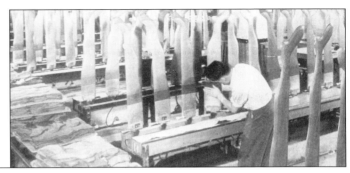

Legs in the air. The trimming shop at the Kayser Bondor factory, Baldock in the 1950s. Stockings were dried on heated leg-shaped forms after being dyed and finished.

the factory. Fully Fashioned eventually joined forces with the American hosiery empire of Julius Kayser to become the largest hosiery manufacturers in Europe. In 1950, following the invention of nylon, Kayser Bondor became the first company in Britain to make and market the famous 15 denier nylon stocking.

One of those who came to Baldock from the Midlands was Mr Albert Vaughan. Right up to the war, Albert had to work either a 10-hour shift from 5 am to 3 pm or a 12-hour shift from 3 pm to 3 am, with a six-hour shift on Saturdays. There was only one tea break on each shift. Now in his nineties, Albert told me: 'We were making mainly silk stockings. The "legger" machines – as they were known – were 40 feet long and knitted 24 stocking legs at a time. On a night shift, if you could make 15 dozen pairs, you were doing well. To work at their best, the machines had to be maintained in a temperature of 70-80 degrees Fahrenheit. It was very hot work because you also had to walk up and down each machine checking that everything was working. I once estimated that I walked about 6 miles on each 12-hour shift. On Saturdays we had to clean the machines before we went home. In the thirties I was earning about £2.10s (£2.50) a week for 60 hours of work. Bondor went to a lot of trouble to

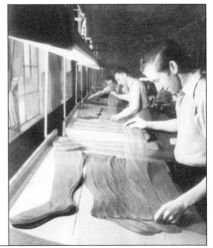

Kayser Bondor graders checking to ensure perfection prior to packing for despatch.

provide some excellent sports facilities – swimming pool, tennis courts, bowling green – but quite frankly we were usually too tired to make use of them. 'After the war conditions improved. Our pay went up to £4 a week, and shifts were reduced to eight hours. But you still got only one tea break.'

Nylon hosiery manufacture produced an ideal cottage industry for those housewives who were unable to go out to work because of young children. Every stocking coming off the knitting machines was scrutinised for imperfections, and those found to have faults were bundled up in bags and sent off to one of the team working from home. Stella Lupson of St Ippolyts told me: 'We had to go on a course lasting several weeks to learn how to use the small electrically-operated machine that had been specially designed for invisible mending. The nylons we repaired were all white. The factory used to dye them after we had worked on them because colouring helped to hide the repair work. Later on I took a similar job with a dry cleaning company ... Even in the 1960s nylons were still hard to come by and some women would have the same pair repaired several times before throwing them away. It was quite hard work but well paid. I used to earn about £3 a week.'

Even though many women had turned their hands to men's jobs during the war, Ann O'Dell of Hitchin still made front page headlines in the Hertfordshire newspapers when she left school in 1956. At the age of 16 she joined George W. King's engineering company at Stevenage as the county's first female engineering apprentice. 'I suppose it was quite a thing at the time,' she recalls. 'I really wanted to become a draughtswoman but our neighbour, Mr Galpin, who was company secretary at Kings, suggested that I apply for an engineering apprenticeship. So I went for an interview and was taken on.

'I attracted a few curious looks for a while but was soon accepted by the apprentices and regarded as just another member of the team. I learned how to operate milling machines and lathes and had to make a metal hexagon for my test piece. My life seemed to revolve round metal. Even the mugs we used for our tea breaks were enamel!'

CHAPTER FIVE
FAMILY AND SOCIAL LIFE

E ven in the Forties and Fifties, the rigid social classifications imposed by the Victorians still held sway among many families. Youngsters from 'respectable' households were still being made aware of their position from an early age and were even prevented from playing with other perfectly respectable children, just because they weren't considered 'our sort'. While young, we took these social barriers for granted. It wasn't until the arrival of the permissive Sixties, when we were independent of our parents, that we began to shake them off.

Janet Newman (seated) and her sister Patricia – 'One foot in front of the other, ankles crossed!'

As part of their early training to be 'young ladies', Janet Newman and her sister Patricia had to accompany their mother on visits to friends for afternoon tea. 'While they chatted for what seemed hours, my sister and I had to sit side by side on a *chaise longue* with straight backs and one foot in front of the other, or ankles crossed if our feet didn't reach the floor.' Janet recalls. 'Whilst retaining this position we had to keep one hand in our lap and then lean forward to take one of

the dainty cucumber sandwiches offered to us. More often that not a piece of cucumber would fall out onto the floor causing frowns all round. So you can imagine our anxiety when we were offered a sandwich filled with runny honey!'

One of their mother's friends was Miss Paternoster, whose family owned Paternoster & Hales, a newsagents and stationery business in Sun Street, Hitchin. Miss Paternoster's great claim to fame was that for a brief period in the 1930s her shop had been patronised by the Royal Family. While staying at the Bowes Lyon family home at nearby St Paul's Walden Bury, The Queen Mother – then Duchess of York – would take her two young princesses to Miss Paternoster's shop to buy pencils, crayons and books. Once, the future Queen Elizabeth II was seen emerging with a copy of the latest *Mickey Mouse Annual*. However, it was in Miss Paternoster's flat above the shop one day that young Janet Newman learned that other parts of the premises had also been patronised by royalty.

'The only way to relieve the boredom of these tea parties was to ask to go to the lavatory,' Janet recalled. 'Miss Paternoster's lavatory was at the top of a long flight of stairs ... to get on it, you had to climb three more steps, the top one of which was very narrow. So for a small girl in a hurry it wasn't easy getting your knickers down and pulling yourself up onto the seat. I managed but, when I tried to get off, I slipped and fell down the three steps with a most tremendous crash ... Miss Paternoster ... dashed to the bottom of the stairs and, instead of asking if her young visitor was all right, shouted: "Janet Newman! If Princess Margaret Rose can get off that lavatory without making a noise, you should be able to as well!"'

Children were avid readers. Whereas the common cry of exasperated parents nowadays is 'Are you still glued to that screen?', in the Fifties it was 'Have you still got your nose in that book?' Comics were popular too: *The Rainbow*, with Tiger Tim, and *The Children's Newspaper*; but in some households comics were vetted, with *Dandy* and *Beano*, which contained such disreputable characters as Desperate Dan and Keyhole Kate, being considered undesirable by some parents. The most intriguing comic innovation of the 1950s was the highly popular *Eagle*, featuring the adventures of Colonel Dan Dare and his space ship crew on their journey to Mars. 'The magazine you're glad to have them read' was how *Eagle*

advertised itself. But I wonder how many children of that time realised that the comic had a strong social conscience, once explained in a full-page advertisement in *Picture Post* in 1952. Here is part of the text:

'A boy's longing for adventure and excitement may often cause great and reasonable anxiety. Adventurousness may be turned to violence, excitement to cruelty by a variety of vicious influences. And here cheap second-rate comic strips are much to blame. They warp and distort a boy's sense of values and give him a false outlook on life. Here, no creed of violence is preached; no tawdry morality or cheap sensationalism or worship of the superman ever appears. For Eagle *is edited by a clergyman and – underlying the tales of space exploration, the exciting strip cartoons and features on sport, science and nature – there is a Christian philosophy of honesty and unselfishness.'*

In those days – when shops and stores waited until December before displaying Christmas goods – books were a popular gift. Ann Waine, recalling her childhood Christmasses in Watford, writes: 'My elder sister Linda and I each had one large present and a pillowcase full of smaller presents (mainly from relatives) ... The season started on Christmas Eve – with Mum making our sausage rolls and mince pies on the kitchen table that afternoon – and ended on Boxing Day ... a week's holiday was considered a luxury.'

On the theme of hobbies, Ann says, 'Children today would probably think our hobbies ... "tame". Lots of us collected stamps, we made scrap books, and had lots of pen friends ... I still love to receive letters. Linda had more pen

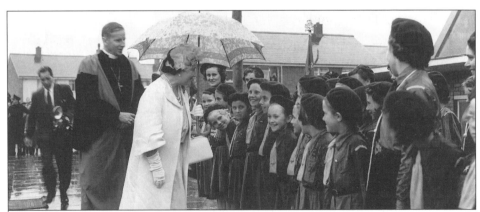

A wait in the rain for these Brownies is rewarded by a word with The Queen Mother during her visit to Stevenage in 1956.

friends than I; she used to write to people all over the world. When we were older, our evenings were taken up with the Brownies, ballroom dancing lessons and confirmation classes.

'On Saturday mornings,' Ann continues, 'we always listened to *Children's Favourites*, hosted by Uncle Mac. While we listened to this, Dad would collect up all the family's shoes and clean them in the back room. Every Sunday morning the house smelt of roast. *Family Favourites* was on the wireless and Dad would be doing his crossword with his feet up on the chair. It was most unusual to be allowed out to play on Sunday as it was a family day. Often we would walk up the road along High Elms Lane (before the crematorium was built!) where there was a bluebell wood. We would pick bunches of wild flowers and look for birds' nests, although Dad never let us take the eggs or even touch them. Sunday tea might be tinned salmon (if you had visitors) with crumpets, celery and home-made cake. Food in those days was pretty basic ... Sunday, roast; Monday, cold meat and pickles; Tuesday, mince (still the remains of the roast!); Wednesday, stew; Thursday, liver and onions; Friday, fish and chips; Saturday pease pudding and faggots.'

Jean Hayes, now living in Buntingford, remembers the simple pleasures enjoyed when she and her husband moved to Cheshunt in 1950. 'We were ... on a bit of 1920s ribbon development between Cheshunt and Goffs Oak. Behind our long back garden were fields, then nurseries, then more fields. They are probably all built on now. We used to stand at the bottom of our garden on summer nights and listen to the nightingales in the hedge on the far side of the field. They were still there well into the Sixties because my second daughter used to

A Christmas advert for Trex vegetable fat featuring the popular TV cook Philip Harben.

Washing machines began to make life easier for some housewives.

complain that the noise they made woke her up! Cuckoos were plentiful and a barn owl hunted the field nightly. Our lives were certainly very different in the 1950s. I did all clothes washing by hand until my third child was 18 months old, when a second hand twin-tub changed my life. The children used to play outside without fear. They'd disappear into the field with the cows and make camps. They used to earn pocket money by collecting buckets of manure. We grew lovely vegetables. Nobody worried about strangers, even though there was a gypsy site not far away.'

Mollie Moulding was also involved in the family's gardening activities: '... it must have been a struggle for my parents because I was one of ten children. My father rented five allotments from the council so that he could grow food to feed us. And we children had to work up there with him for several hours each week, digging, and sawing wood for the fire.'

Some people's vegetables occasionally received an extra 'boost', as described by Barbara Boxshall: 'Our privy was in the coal shed in the garden. There was no light – just a candle. The seat was a plank of wood with a round hole cut in it. There was a cess pit somewhere under the garden and when it became blocked the sewage came up in the vegetable patch. Fantastic manure I should imagine. Ugh! My dad used to dread the job of sorting the blockage out.'

Susan Hunt of Hertford recalls: 'In 1950 – when I was 10 years old – our home in Rickmansworth had no fridge, no TV, no washing machine, no central heating nor any real labour-saving devices until late in the 1950s. There was a mangle for wringing water from clothes before they were hung on a ceiling rack to dry. This seemed to be constantly full of clothing in different stages of drying. 'We also had a terracotta dish and cover for keeping milk fresh and a meat safe with a metal mesh door for the same purpose.

'We had a gardener called Mr Knight who came one full day a week for a minute wage. He smelled sweaty when I used to join him in the potting shed, where he ate his lunch – a thick bread-and-dripping sandwich and cold milky tea that he drank from an old screw-top beer bottle. On wet days my mother would invite him into our kitchen for a mid-morning cup of coffee. He would hang up the sack that he wore across his shoulders to keep off the rain and then sit down at the kitchen table. When my mother handed him his large cup of coffee, he would proceed to pour small amounts from the cup into the saucer. Then, after blowing on the contents, he would carefully lift the saucer

and tip the contents into his mouth with loud slurping noises. This operation never failed to amaze and delight me!'

Many young couples of the 1950s began married life in property rented from a private landlord. Mrs Eileen Burns of Bengeo began hers in a bungalow at Hertford Heath, rented from a family friend for £2 a week. 'My husband worked for the railcar manufacturers, Wickhams of Ware, for a weekly wage of £12,' she writes. 'The bungalow had an open fire in the lounge and a coke boiler in the kitchen. The fuel was 7s (35p) per hundredweight. There was a *very* small selection of foods at this time. Milk was delivered from the nearby farm, groceries from the village shop, and I fetched freshly baked bread from the baker's shop. We always enjoyed a cooked breakfast with daily eggs – no thoughts of high cholesterol! We rarely dined out; the fashion then was to invite friends for afternoon tea with home-baked cakes and biscuits.'

John and Betty Amess moved to Stevenage in 1957, after John had found a job as a draughtsman with English Electric, one of the town's major employers. Both John and Betty stressed how important it was for newcomers to Stevenage to adopt a pioneering spirit. 'You really had to make an effort to go out and make friends quickly,' Betty said. 'As none of us had any family living nearby, those with young children got together and arranged a babysitting

Pram pride. Mothers outside a Hertfordshire County Council mobile clinic in the 1950s.

Prams, like cars, became status symbols for a while.

rota so that parents could go out together for the evening from time to time. There were so many children's birthday parties that those of us with boys reached an agreement that we would never spend more than 1s 9d (9p) on presents. That allowed 1s 6d for a Matchbox toy and 3d for the card. In fact, they became known as the one-and-nine parties!'

Because Stevenage then had no hospital facilities, John and Betty's second baby was born at home. 'Just after his birth, we had the additional problem of a plague of earwigs,' Betty recalled. 'The builders must have disturbed something in the soil because they were everywhere. Millions of them. I was so worried about them getting on the baby that I stood each leg of his cot in a jam jar containing disinfectant!'

After the excitement of moving into a new home had worn off, some young couples began to feel a sense of isolation and loneliness, resulting in what became known as 'new town blues'. John Amess estimates that about five per cent of people who came to start life in Stevenage went back to their families in London. 'One of our neighbours was here only a week before deciding that she couldn't stand the life and left. The weekends, in particular, could be very lonely,' he told me. On that same theme, Babs Bradley writes: 'When we left our families behind in London, we couldn't have known how much we would miss them. Perhaps it can be best summed up by a single incident which I experienced in our first few weeks at Stevenage and which I have never forgotten. Late one night I went outside to put the milk bottles out and a man was standing by his garden gate a few houses along from us. Suddenly he looked up at the sky and cried out "Please God, make something happen!" I went back indoors and wept.'

It was the advent of television that brought Annette Britnell's family from London to Welwyn Garden City in 1956. Annette writes: 'Dad used to run the *Black Horse* in Holloway but trade began to drop off as soon as people bought their first television sets. Instead of going out for a social evening in the

pub, they would send someone up for a jug of beer and take it home to drink while watching TV. Trade became so bad that my brother and I both had to get jobs to keep the pub going. Then Dad saw an advert about a new London overspill estate being built at Howlands in Welwyn Garden City ... so he took a job as head waiter at the Parkway Restaurant in the Welwyn Department Store (now John Lewis) ... we reached the top of the housing list and were finally offered a three-bedroomed terraced property ...'

The new domestic pastime of watching TV meant viewers had to develop the new skill of eating without taking their eyes off the screen.

Memories of childhood visits to relatives and family friends are recalled with particular affection, providing interesting images of the lifestyles of the older generation at that time. Here are some from Susan Hunt of Hertford: 'Sometimes, if my parents were going out for the evening, I would spend a Friday night with my Aunt Daisy in Victoria Street, St Albans. It was a little terraced house with a front parlour that you stepped straight into. Then, down two steps to the back room, on to the little kitchen (which had one mains tap) and out of the back door to the coal-hole and privy, with its cut-up newspaper on a string! We had chamber pots in the bedrooms and these had to be emptied in the morning. There was no bathroom. For all hot water, kettles had to be boiled on the gas stove and you washed with a jug and bowl. There was a zinc bath which would be placed in front of the fire in the back room and filled from a kettle but I think it was not overused!'

With the price of televisions beyond the pockets of many, most people opted to take advantage of one of the many rental schemes on offer.

CHAPTER SIX
KEEPING CLEAN AND HEALTHY

As a rule, Friday night was 'bath night' for most families during the 1950s. Of course, there were other occasions when particularly grubby children returning from play would be stood in the bath in a couple of inches of lukewarm water with instructions to 'wash up as far as possible and down as far as possible'; however, the 'possible' was usually washed only on Friday night. Even then, thrifty mothers, still mindful of war-time restrictions, would allow only five inches of water in the bath. That was the amount recommended by the Ministry of Fuel and Power, a limitation observed even by the King and Queen, who, throughout the war, had a red line painted round the inside of their bath to ensure that they didn't use too much water. The rest of the week, the hand basin was used; this also served as a foot basin for the more athletic. Hair washing (for boys, at least) was also far less frequent than it is nowadays: perhaps only once a month.

Barbara Boxshall, writing about her childhood in Abbots Langley, says: 'At one point, the only bath we had was a tin one. On bath night in the back room we would place an old wooden clothes-horse around the bath, draped with sheets for privacy. I was lucky because I was always first in. After me, it was the turn of my brothers and then my parents. This was the only room with a fire in it. The front room was for special occasions such as weddings or funerals. I had a bedroom that was more like a cupboard in the corner of my parents' room. My Nan and Grandad lived a couple of doors away. They had a real bath but, because it had no taps, it had to be filled from the sink. When not in use, it was covered with planks and served as a table!'

Whilst on the subject of washing, another Fifties memory – recalled more by women than men – was of the great excitement when soap rationing ended. Throughout the war, and for some years after, the only soap available was functional and unromantic – brands such as Wrights coal tar, carbolic, Lifebuoy and Sunlight. As Annette Britnell of Letchworth reminds us: 'Throughout the post-war years all we could get were those dreary blocks of unscented yellow soap. Some were about a foot long, and Mother would have to cut off a piece for us to use. When rationing ended, the manufacturers were allowed to make scented soap again. I still remember the feeling of luxury the first time I washed with a bar of pink, perfumed Camay soap. I used to walk to school smelling my hands as I went along!'

Two ads of 1953 reflecting the move from practical to luxury soaps.

Ann Waine of Chipperfield makes the point that, because very few houses had central heating, in the Forties and Fifties families were closer as a unit because they spent far more time sitting together during the winter months. 'To keep warm, the whole family *had* to sit around the fire together to watch TV or play games,' she writes. 'On really cold nights my sister and I would get undressed for bed in front of the fire and then make a dash upstairs. Some mornings we used to wake up to find ice on the *inside* of the window. No wonder folks didn't wash so much in those days!' Barbara Boxshall adds: 'On really cold nights I was known to go to bed in a jumper, socks and gloves – and on one occasion I even wrapped a scarf around my head!' Chilly points echoed by Bridget West of Berkhamstead: 'Our family of six would huddle round the fire on a winter's evening. The best bit was listening to *Saturday Night Theatre* on the radio. After that we went

to our cold beds in a cold bedroom clutching a stone hot water bottle. Thank goodness for them! Although they could be lethal. I eventually discovered rubber hot water bottles and finally got rid of the chilblains on my knees and feet.'

Although the question 'Did you Maclean your teeth today?' was asked in every magazine and newspaper they opened, most parents failed to press home the importance of oral hygiene. They would occasionally yell 'TEETH!' as the children disappeared up the stairs but, because the bathroom was usually freezing cold, the brushing operation would never last more than a few seconds during the winter months. The benefits of gum massage and plaque removal were unknown. Consequently nearly everyone from that generation has a horror story to tell about a visit to the dentist.

In 1942, when I was nine, my parents took me to my first feature film – *Bambi* – but the treat was totally ruined by the fact that I knew that I was due to have two teeth extracted under gas the following day. The fear turned out to be fully justified when the attendant doctor failed to put me out and my mother and all those in the waiting room heard me screaming, 'I'm not asleep yet! I'm not asleep!' I was returned to her shortly afterwards minus the two teeth but with lips torn and bruised by the extractor as the dental surgeon ignored my cries and struggled to get the instrument into my mouth. We changed dentists after that, but it was five years before my parents could persuade me to make another visit. Plagued by toothache and gumboils throughout my formative years, I used to envy my father. In 1922, as a present for his thirtieth birthday, his parents had 'treated' him to what was known as 'the complete clearance', that is to

Two significant toothpaste ads. The Macleans ad was designed for the Festival of Britain exhibition of 1951; the 'tingling-fresh' Gibbs SR was the first advertisement to appear on British television, September 1955.

say, the removal under gas of all his teeth: top and bottom, good ones and bad. During a bout of toothache just before the experience related above, I pleaded with my mother to let me have the same treatment as my father and couldn't understand why she wouldn't hear of it.

Peter Cherry, a retired bank manager living in Tring, was more successful in this respect. 'As a youngster I had very bad teeth,' he writes. 'As a result, at the age of 28, I had them all extracted and was fitted with a full set of dentures. Leading up to this event, which I have never regretted, were many dental visits. My dentist was a tall Scot, slim and athletic, and my abiding memory is of sitting in *the chair of pain* and hearing him approach down the corridor with his metal-tipped shoes beating a martial tread on the linoleum – no pile carpets and fish tanks in those days. I mentioned the chair of pain. I was never disappointed.'

Another ordeal remembered by thousands of children during the Forties and Fifties was the 'conveyor belt' system adopted by hospitals and health departments for the removal of tonsils and adenoids. Bridget West was one of the children treated in that way. 'I remember it vividly,' she writes. 'It was in 1942, and I had just sat my scholarship exam for Watford Grammar School. At the hospital the mixed group of boys and girls were led into a room in pyjamas and seated on chairs round a wall. The two nearest the door were given mackintosh capes and little mob-caps. Then in turn they walked across the corridor to the operating theatre. As the first child was wheeled out of one door, so the next walked in. After a few minutes, the first child's cape and cap were brought back for the next in line, while the rest of us sat silently waiting for our turn. What an outcry there would be today at such methods!

'The following day everyone was told to get up, get dressed and go home. Everyone that is, except me. My tonsils were heavily infected and had to be removed completely rather than being clipped. I didn't know this until I was not given my clothes and instead was wheeled off to the adult ward, where I had to stay for a further 10 days. It was while I was there that my mother brought me the news that I had passed my scholarship exam.'

Susan Hunt of Hertford also remembers her tonsillectomy, but for a rather different reason. 'At the age of 10 or 11 I was one of the "conveyor belt" tonsils children. When taken to the specialist for my frequent bouts of sore

throat, she declared that I looked like something out of Belsen and accelerated my admission to hospital. During my stay, while emptying my chamber pot into the lavatory, my mother dropped it, breaking not the pot but the lavatory bowl. Matron came down on her like a ton of bricks and my father had to pay up for a new loo!'

While on the subject of matrons and hospital discipline, I am indebted to Joan Goodall of Letchworth for providing a graphic illustration of what life was like for junior hospital staff during the early years of the National Health Service. In 1949, at the age of 17, Joan Wells, as she then was, began training to fulfil a long-held ambition to become a nurse. 'My decision not to stay on in the sixth form upset my parents a great deal,' she writes. 'They considered that nursing was little more than slavery and the last profession for an educated girl. My first salary as a trainee was to be £65 *a year* – about £1.25 a week – plus my keep. Mum and Dad tried for six months to persuade me to stay on at school, but I was determined to leave, and when my mother took me to the hospital on the first day she wept and was inconsolable.

'As the newest recruit, I was at the bottom of the pecking order and had to cope with such jobs as helping orderlies and cleaners, handing out and collecting bedpans, counting plates or sweeping the wards. I have never forgotten how harshly the sisters treated me,' Joan writes. 'Once, when I had an infected arm, this sister said she would treat it and slapped a boiling hot poultice on. "There you are," she said, "Now you will always remember to test the temperature of a poultice before you put it on a patient." It was called discipline and it was a lesson well learnt that stood me in good stead when I began my training in 1950. We all got on very well together and I learned a lot from the other students, who were two or three years ahead of me. I did three months on days and the next three on nights, working seven 12-hour night shifts before having three days off. Sometimes we worked 14 nights in a row. I was 17 years and six months old when I had to lay out a dead body. It was in the night and I was scared stiff. We had to carry the person out on a stretcher. Her name was Winifred, a lovely lady in her late thirties, who had a son and a little girl. I had been nursing her and got to know her well. I shall never forget the night she died.'

However, being the junior provided occasional happy moments as well. Joan recalls: 'The food was very good. We had a jolly chef called Mr Hunter, who

cooked lovely meals. Because I was still under 18, I was the only member of staff with a child's blue ration book.

'One day, Mr Hunter swept into the staff dining room holding a huge silver salver high above his head and laid it before me. On it was a single banana that had been delivered to the hospital store especially for me, because at that time only children were entitled to receive bananas. It was the first one we had seen one since 1939. Of course, the patients were the top priority when it came to food. They were treated like lords and ladies. We were forbidden to serve a meal if gravy had been splashed on the rim of the plate and no drink was served unless it came directly from the kitchen on a tray.'

During the early 1950s when Joan began her career, penicillin was the current 'miracle drug'. Still in its infancy, it was given, not in tablet form, but by injection every three hours. The antibiotic streptomycin had not yet been discovered, and until the development of the Salk vaccine in 1954 there was no way of preventing poliomyelitis. Tuberculosis was rife, with patients spending months in hospitals and sanitaria taking bed rest because that was the only known way to treat the disease. Before steroids were discovered in 1952, some skin conditions were very difficult to treat, Joan Goodall says. 'We had special skin wards where patients would have to remain for several weeks, being treated with daily applications of tar-based creams, gentian violet, potassium permanganate baths and calamine lotion by the bucketful. Most patients would respond to the care, but eczema patients would break out with weeping skin when they were due to go home and we would not be able to release them because they would be unable to treat themselves once at home.'

Beecham's powders, in their little paper sachets, were a feature of most 1950s' medicine cabinets.

Limited drugs meant that sexually-transmitted diseases were still a major problem during the post-war years. Joan Goodall recalls: 'We still had children being born with congenital syphilis – a disease common during and after the war. Today the disease is still around but all mothers are now screened during their antenatal period and treated immediately, so you never see children born with syphilis nowadays.'

While on this delicate subject, I am reminded of how the Royal Air Force warned its men of the dangers of such diseases. One morning in 1952, during my eight weeks of basic training, our drill instructor, Corporal Bates, announced: 'There's a special treat for you today, lads. We are going to the pictures.' He marched us off up the hill and into the Astra Cinema, as all RAF camp cinemas were known. Half an hour later we emerged feeling slightly sick, having been brain-washed into celibacy by a couple of short Air Ministry films. These featured a number of unfortunate servicemen, naked apart from a black mask, displaying their pustulous genitalia as a warning of what would happen to us if we 'put it about and got the clap', as VD was familiarly known in those days. A series of colour photographs on the same topic was to be found in the huts in which we airmen were billeted. Little wonder that, when 2554278 Senior Aircraftman Whitmore R.T. was demobbed in 1954, he was still a virgin!

> *Smoke, smoke, smoke that cigarette!*
> *Smoke, smoke, smoke until you smoke yourself to death*
> *Tell Saint Peter at the Golden Gate that he'll simply have to wait*
> *'Cos you've gotta have another cigarette!*

Despite that warning in Phil Harris's patter song, few were aware of the health hazards of smoking. The link between smoking and lung cancer had been

A selection of 1950s ads designed to emphasise the social value of smoking.

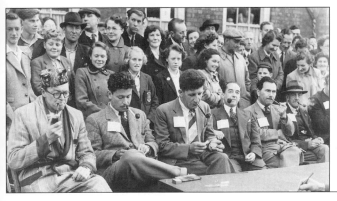

No health worries here, only deep concentration to see who can make a pipe bowl of tobacco last longest. The competition was a feature of coronation celebrations at Baldock in 1953.

suggested as early as 1946 but it was a long while before any really positive steps were taken to warn young people about the dangers. Cigarettes were one of the few commodities not rationed during the war and were available at special low prices to the men of the Royal Navy. Smoking was promoted in advertisements by film stars and sportsmen, and some manufacturers went so far as to suggest that cigarettes could actually *benefit* one's health. They helped you to concentrate; they helped you to relax; they helped you to make friends. Craven 'A' cigarettes were – the manufacturers claimed – 'made with a rich tobacco that is so kind to the throat'. In the Festival of Britain programme for the South Bank exhibition, Ardath Tobacco Company – who made State Express cigarettes – proudly advertised themselves as 'Cigarette manufacturers, by appointment to HM King George VI'. The following year the king was dead – from lung cancer.

To add to the lung damage caused by cigarettes, there was smog – that choking combination of domestic and industrial smoke and fog that would hang like a sulphurous shroud over towns and cities. Often, visibility would be reduced to a few feet and breathing would become painful. As is recalled in the next chapter, traffic could be forced to a standstill. By 1953 the situation had become so bad that the government decided that people with serious heart or lung diseases could qualify for anti-smog masks on the National Health Service.

An early 1950s ad pioneering the sale of 'smokeless' fuel.

63

CHAPTER SEVEN
GETTING ABOUT

Transport – and sometimes the lack of it – made regular headlines in the new towns during the 1950s. By the middle of the decade, government cut-backs, coupled with a national brick shortage, meant that Stevenage New Town was not growing as a single cohesive unit, as originally planned, but as three widely-spaced neighbourhoods. There was a big residential area adjacent to the old town and another in the Broadwater district some miles away. The industrial area, cut off from the residential neighbourhoods by the Great North Road and the King's Cross-Edinburgh railway line, made up the third.

Barry Bremner of Letchworth, a former reporter on the *Herts Pictorial*, writes: 'The first problem was that the new town's main shopping centre had not then been built, so to reach the High Street shops in the old town housewives had a long bus journey that took them all round the remote outposts of the new town before it arrived at the High Street.

'The Broadwater housewives endured the inconvenience and expense of the bus journeys for a while until a certain Mrs Molly Beecheno, the wife of an international trade union leader, and a group of neighbours staged a sit-in on a double decker bus at a bus stop close to their homes and

Moped and scooter manufacturers were quick to take advantage of the petrol shortage to advertise the low fuel consumption of their machines.

refused to pay their fares.' Barry was the apprentice reporter sent to cover the story.

'I was dragged onto the bus for an interview with Molly, the ringleader, a fierce but attractive blonde lady, who was telling a London Transport inspector in no uncertain terms that she was not going to allow the bus to move until she had spoken to the Press ... She thrust into my hand a typewritten sheet of facts and figures headed: "The Broadwater Housewives' Revolt" ... The story appeared the next day under headlines such as: "London Transport bus hijacked by revolting housewives". As it turned out, the protest was not in vain because London Transport changed the routes in the New Town and reduced the fares soon afterwards.'

The second dispute was a far more serious one and is recalled by both Barry and *Hertfordshire Express* reporter Don Hills. For hundreds of workers living in the Broadwater area, the only way to reach their factories was by taking a dangerous cycle ride along part of the Great North Road. Don writes: 'To get to their factory, workers had to cross or cycle along a derestricted part of the Great North Road. I can remember at least two fatalities involving cyclists after dark.' Barry Bremner adds: 'Inadequate local bus services could not cope with the thousands of workers, so almost all, including office staff, cycled to work and back in swarms. The A1 was still the nation's only major trunk road and was totally overloaded. During the winter months it became a death trap for the rush hour cyclists on the unlit stretch. The government of the day took no notice of the strong local demands for a bypass. Then, in the space of two weeks, three young men were knocked off their bikes by heavy lorries, so the workers decided to take the law into their own hands. They staged a series of Friday night protest marches along the Great North Road, when literally hundreds of them walked slowly along, wheeling their bikes – one big human phalanx that occupied the entire width of the road, blocking traffic from both directions. It took almost two hours for the column to reach Broadwater.'

For the second march the workers were joined by trade union leaders and local councillors, as well as a number of Fleet Street reporters. After a third Friday evening of traffic chaos the Government and development corporation eventually conceded that urgent action was necessary, and a few weeks later a Bailey bridge was built to take cyclists across the A1 to the industrial area. The bridge remained in service for several years until the full road system had been

*Part of the 26 miles
of cycleways built
in Stevenage
from 1958.*

completed and a proper bridge built. The Stevenage bypass itself – now part of the A1(M) motorway – was eventually opened in 1962.

In fairness to the planners, it should be said that Stevenage's transport system had been designed to cater for cyclists right from the outset and today includes a 26-mile network of cycleways and underpasses that link the various neighbourhoods quite independently of the road system. It has to be remembered that, in the 1950s, something like 40 per cent of local populations cycled to work or school each day. Nobody foresaw the enormous rise in car ownership that was on the horizon, so many of the main roads eventually proved far too narrow and had to be widened.

An early sign of the coming boom in car ownership appeared in 1953, when Ford launched what they described as 'the world's cheapest four-cylinder car'. The Popular, as it was known, was little more than a revamped version of the old Ford Anglia and it sold for £390. Petrol, no longer rationed, was costing only 3s (15p) a gallon. Yet, when I began work on the *Hertfordshire Express* in 1951, none of the editorial staff owned either a car or a motorcycle. We went on our assignments by bicycle, bus or train. For the first few years of the 1950s, new cars were in such short supply that purchasers lucky enough to get one could sell the vehicle on for £200 more than they had just paid for it. So to protect their market, dealers made buyers sign a covenant undertaking not to sell the car they had just bought for at least two years.

A bicycle was sufficient for my first job on Monday mornings. This involved meeting up with my opposite number on the *Herts Pictorial* (then Barry Bremner) to pedal round the town and call on 11 clergymen of assorted denominations, from whom we would collect details of forthcoming weddings and other innocuous little stories. My favourite was Father Kenny, a jolly Roman Catholic priest, who, although approaching his three-score years and ten, was often seen ripping through Hitchin astride his Triumph 500 cc motorcycle; black clerical gear supplemented by a brown leather flying helmet and gauntlet gloves. Our weekly call time at the presbytery would double as he recounted his latest exploit. 'Got up Offley Hill at 90 the other day, lads. Absolutely clear road, so I didn't even have to change down. Nearly left the bike when I hit the brow, mind you!'

My first motorcycle was rather slower than Father Kenny's. It was an ex-War Department Corgi, costing £25. These tiny low-slung motor scooters, developed for the D-day invasion of Europe, were designed to fold up so that they could be parachuted to front line troops, who rode them into the ground for a few months and then threw them away. Mine had a maximum speed of about 25 miles an hour and, because I drove it at full throttle most of the time, it tended to conk out rather frequently. So it was only a matter of months before my father announced that he would no longer subsidise the repairs and I sold it back to the garage for £10. In 1955, I entered into my first hire purchase agreement and bought a brand new Royal Enfield 125 cc

Easy riders. A group of lads from Hemel Hempstead on a 1950s motorcycling jaunt.

The author's wife, Wendy, on their Lambretta in 1956.

motorcycle. This prestigious step up in my personal transport arrangements is remembered by Barry Bremner, 'I was still riding a bicycle when you bought the motorbike,' he reminded me. 'It made my Monday morning pedal round Hitchin much easier because you would let me hang on at the back. It was probably illegal – but it reduced my journey time considerably!'

Like other young couples in the 1950s, my wife, Wendy, and I were seduced by the popular advertising slogan '*Get Around Better – Travel Lambretta!*' The graceful Lambretta motor scooters, like their rival Vespas, had been developed in Italy, where the girls in their petticoated 'New Look' dresses set a rather dangerous trend by perching side-saddle on the pillion seat as their boyfriends whisked them around Rome. A few of us tried it out over here until the police put a stop to it. For a year or two we thought ourselves quite chic, scooting up to London in our duffle-coats and white crash helmets to see a West End show. It seems unbelievable now that we were able to leave the scooter parked against the kerb outside Hamley's toyshop in Regent Street with no fear of its being either stolen or impounded.

British manufacturers produced a number of scooters and mopeds in an effort to match their continental rivals but were never able to knock the Lambretta off its perch. Perhaps most eye-catching of the British products was the handsome Dayton Albatross scooter, launched at the Earls Court Cycle show in 1955 and boasting a fuel consumption of 84 miles to the gallon while cruising at 50 miles an hour.

I eventually traded in my two wheels for four and bought a second-hand BMW Isetta bubble car. This turned out to be far slower than my Lambretta,

but was particularly useful when driving in fog. Being much closer to the ground than any other drivers, I found I was more easily able to see the catseye reflector studs that marked the middle of the road. Returning from London one night when the visibility was almost nil, Wendy and I found that other motorists were content to tuck in behind us as we made our way up the Great North Road at a steady 20 miles an hour. When we reached Borehamwood, I noticed that we were low on petrol and decided to turn off the main road into a garage. When I got out of the bubble car I found that seven motorists had followed me onto the forecourt – not to buy petrol but to wait with us so that we could continue leading them up the A1!

It is easy to forget just how bad London fog was in the middle of the last century. Intensified by smoke from industrial and domestic chimneys, it assumed a yellow sulphurous quality and became known as smog. It reduced visibility almost to nil. The bigger Hertfordshire towns close to the capital suffered equally. Susan Hunt of Hertford remembers: 'On Saturday evenings my parents and I would often go by car to the Empire cinema at Watford and I have memories of several times having trouble with the fog. On one occasion we came out of the cinema into a real pea-souper. It was so thick that my father had to ask my mother to take his big white hanky, get out of the car, and walk in front so that he could see where he was driving.'

A popular car for young couples in the 60s, the Triumph Herald boasted 'a fantastic turning circle.'

One for the family. In 1957, the Vauxhall Victor cost £485 – plus a little matter of £243.17s.0d purchase tax!

The 1956 Jaguar – only top-of-the range cars like Jaguar and Rover had automatic transmission.

Throughout the 'pre bypass' days of the 1950s, the lives of people in the north and west of the county were frequently disrupted by streams of heavy goods vehicles thundering through the ancient streets of their towns and villages. Lesley Webb recalls: 'In 1956 my family lived in an old house in Bridge Street, Hitchin, which was then a through road. Our lives were made almost unbearable by huge lorries from the Bedfordshire brickfields taking deliveries to building sites in Stevenage. The house rattled every time one went by. So much so that my father and brother Tony would have to go round with a hammer to knock back the nails that had risen up out of the floorboards because of the vibration. One day, a large old brick building just opposite us collapsed into the street. We were sure this was caused by heavy traffic vibration.'

There was more upheaval for people in west Hertfordshire when work began on the first stage of the M1 London to Birmingham motorway near Watford. Huge machines cut a swath across farmland between Hemel Hempstead, St Albans and Redbourn before leaving the county just north of Harpenden. Disruption was not confined to the immediate area; the work called for millions of tons of gravel that had to be transported to the area from pits up to 15 miles away. For two years or more the tranquility of many Hertfordshire villages and country lanes was shattered by the noise of heavy lorries loaded with gravel from newly-opened pits.

The 1960s boom in car sales brought undreamed-of prosperity to many independent garage owners across the county – both to established companies that had survived the war years and to new ones set up afterwards. By the 1950s some towns had as many as a dozen vehicle dealerships and repair businesses, all doing a brisk trade. One remarkable success story concerns a company founded by Harry Pilling of Hemel Hempstead in 1946. When he came out of the Army, Harry decided to make use of the engineering expertise that he had acquired during his war service. So he borrowed £20 and set up business as a coachbuilder in the backyard of the old Artichoke public house at Boxmoor. There he began converting old wartime lorries and trucks for peacetime use. By 1997, when Harry's sons Graham and Kevin celebrated the 50th anniversary of their late father's company, their business was achieving an annual turnover of more than £30 million! The Pilling Motor Group is still based at Hemel Hempstead and now has a new dealership in Welwyn Garden City as well as in two other counties.

A 1940s snapshot of Harry Pilling, founder of the Pilling Motor Group, with one of his first coachbuilding conversions.

Kevin – joint managing director with brother Graham – has no doubt that their success is due to inspired decisions taken by Harry back in the Fifities and Sixties. 'My father's first coup was to attract business from a company that did haulage work for the local gas and coke company,' he told me. 'Their vehicles had been commandeered for military use during the war and were in desperate need of an overhaul when they were returned.' As news of his enterprise spread across the district Harry began to acquire a list of regular customers. It was then that he decided to build himself a small workshop. Kevin recounts: 'It was made of scaffolding and corrugated iron sheets but, as each sheet cost 2s. 6d. (12^1/$_2$p), he could only afford to buy one a week, so – as you can imagine – it took him some time complete the building. Then, just as it was finished, a local planning officer spotted it as he went by on a bus and Dad had to take the whole thing down. I don't think he'd ever heard of things like planning consent!'

Kevin remembers his father's next premises, just down the road at King's Langley. He told me: 'My father moved into an old livery stable in Rucklers Lane, which formerly housed the horses that were used to pull barges along the

Kevin Pilling – joint managing director of the Pilling Motor Group – as a small boy in his father's workshop in King's Langley.

An exterior view of the Pilling Motor Company's head office at King's Langley in the 1950s.

Grand Union Canal. Conditions were far from ideal. The workshop still had an earth floor.' It was when Kevin and Graham joined the business in the 1960s that their father decided to expand into sales, and they became one of the first motor firms in the country to take on a Volvo dealership; this at a time when Volvo were still trying to get a foothold in the UK car market. Today, the Pilling Group is believed to be the largest family-owned solus Volvo franchise in the UK and now has an annual turnover well in excess of £45 million.

Another Hertfordshire man who has done more than most to preserve tangible memories of British transport from the post-war years is John Saunders. As a young engineer, John joined the de Havilland aircraft company in 1949 and spent some years working on projects involved with the development of the Comet airliner. Later he had a hand in the restoration of the giant doors on the famous Cardington airship hangars, just over the county border in Bedfordshire.

A specialist in the design of lightweight structures, he is now founder-chairman of Norfolk Greenhouses. However his 'pride and joy' is to be found

a little nearer home at the village of Lower Stondon, near Hitchin, where five display halls contain his award-winning collection of vehicles from every decade of the 20th century.

It's the story of a hobby that turned into a big business. Until a few years ago John's collection was one of the classic car world's best-kept secrets. He explained: 'Back in the mid-Fifties I developed a passion for classic cars and began by buying one or two to restore and drive myself. One of the earliest was a Rolls Royce that had one of those speaking tubes so that the passenger could give instructions to the chauffeur from the back seat. For a while I drove it as a family car. We used to drop our older son, Chris, off at school, then my wife, Joan, would enjoy giving me instructions through the speaking tube about where to go next!'

From then on, the collection continued to grow until the couple found that all the outbuildings on their property were full. Groups of people were turning up, asking to see the collection, and Joan found herself on more or less permanent duty making cups of coffee for the visitors. 'So I think she was the one who decided it was time to move the cars away from our home,' John recalls with a smile. 'One day she said she had found a garden centre for sale in Lower Stondon ...' And that was how Stondon Transport Museum came to be opened in 1994.

It is now a truly international collection of more than 350 private, commercial

John Saunders with three 1950s models in his transport museum.

*A Russian SAM missile
from the Cold War
years of the 1960s,
now in Stondon
Transport Museum.*

and military vehicles, from all over the world. Nearly all those on display are in working order. Such is the variety that it ranges from an American 1904 Waltham Orient car, with its 258 cc rear-mounted engine and hickory wood body, to a 1960s Russian Zil tractor unit, complete with a surface-to-air missile and launcher, once the property of the Red Army. 'I picked that one up in East Germany, just after the Berlin Wall came down,' said John. 'It raised a few eyebrows among the Customs men when we drove it off the boat at Harwich!'

John Saunders, proprietor of Stondon Motor Museum, shows the author a BMW Isetta bubble car, identical to the one he drove in the 1950s.

CHAPTER EIGHT
FUN FOR ALL

Throughout the lean post-war years, such luxuries as new toys and ready-made entertainment were still in short supply, so children had to manufacture their own forms of amusement. Model aircraft and kite flying, banned during the war for reasons of national security, enjoyed a swift revival. I well remember the exhilaration my brother Mark and I felt when – after VE Day in 1945 – our father took us up Telegraph Hill at Pegsdon to fly our first kite. Because none were yet on sale in the shops, he had made it himself from brown paper and garden canes, with strips of newspaper twisted and tied to green garden twine to form a tail. It flew beautifully a hundred feet above our heads, and we were particularly impressed when he showed us how to thread an old cigarette packet onto the string and send it spinning up towards the kite, whistling in the wind as it went.

As balsa wood became available again, boys were quick to take up aeromodelling. Joan Cook of Leverstock Green recalls afternoons spent out in the countryside with model aircraft enthusiasts from her neighbourhood around Hemel Hempstead. 'The boys would spend hours making these delicate models,' she tells me. 'They were constructed from thin strips of balsa wood that took hours to glue together. The completed airframe was covered with a special tissue paper painted with aircraft dope to strengthen and waterproof it ... We seemed to be forever chasing across the fields after the aircraft. Sometimes they made only one flight before they had to be taken home for repairs. If they achieved a good landing, they usually stayed in one piece, but more often than not they would end up in a tree or hedge torn to pieces.'

The hobby developed swiftly, first with miniature engines powered by ether, and then sophisticated radio-controlled models. In the middle of the Fifties, Hertfordshire enthusiasts were able to see the country's finest craft performing when St Albans Model Aero Club staged an all-Britain rally on the Handley Page airfield at Radlett – attracting a crowd of 20,000. A town of small tents sprang up along the 2,000-yard runway, as aeromodellers young and old arrived from all over the country. Events included control-line races, aerobatics and dogfights, and a large water tank was provided for radio-controlled seaplanes.

The knock-on effects of the war shaped the way many boys and girls spent their leisure time. Groups like the Sea Cadets and Rangers, the Army Cadet Force and Air Training Corps had no recruitment problems. Malcolm Moulding of Hertford joined the local ATC in 1951, when he was 13. 'Our huts were recycled ones, obtained from various wartime airfields,' he recalls. 'Inside, the walls were still decorated with aircraft recognition charts ...'

As a drummer in the ATC band, Malcolm took part in many celebration parades. 'Hertford was still the county town and many important events took place there. On occasions like the Coronation and Remembrance Days, the fusion of society seemed unbreakable. As the bands thundered out I felt very proud as we marched past the memorial. During Coronation year we took part in an enormous event at St Albans where the Air Officer Commanding

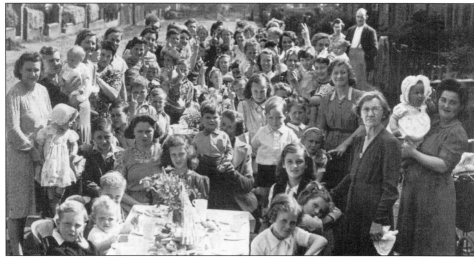

A VE Day party at Alexandra Road, Kings Langley, 1945.

took the salute – although that day in 1953 ended in a party which turned out quite literally to be a bunfight as the cadets started throwing cream buns at each other. At any other time there would have been hell to pay but on this occasion nobody said anything. It was all part of the spirit of the day.'

One common factor mentioned by contributors is how often children were left to their own devices, free from parental constraints or worries about their safety. Bridget West recalls: 'My sister Margaret and I went everywhere on bikes ... trusty wartime machines with black handlebars and black-painted wheels. During the war, my enterprising mother had spotted an old gypsy caravan in a junk yard and bought it for £20. She had it towed out of Watford into the countryside. Margaret and I ... would cycle the 15 miles from Watford to Northchurch Common laden with our bits and pieces. We often slept in the caravan and lived on tins of M and V (meat and vegetables), which we heated on a paraffin stove. On one occasion we set light to the curtains but were quick to put it out ... Other good holidays were at Guide camp, where we lived a truly primitive life and thoroughly enjoyed it. We took big tents we had to practise erecting beforehand. No posh loos, of course; just a trench with a rickety seat!'

Remembering her childhood on the Woodfield estate at Watford, Ann Waine recalls: 'I remember such games as French knots, English and Germans, and cowboys and Indians. We hardly ever watched TV in those days. We seemed

to manage to keep ourselves amused – and out of the way of our mothers – all the time. We swapped beads, ran libraries, dressed up and put on fetes and plays. We used to play on waste ground where the Watford leisure centre now stands. In the summer holidays I would go off for the day, usually over to the woods at

Bridget West and her sister Margaret of Watford, who cycled many miles on their wartime bikes. Restrictions on the use of chromium plating meant that the handlebars and wheels were black.

Woodside to build camps with my friend. Mum wouldn't see us until we returned for tea.

Sometimes our neighbours would build trolleys from pieces of wood and old pram wheels and we would race these up and down the hill.'

'Soapbox' trolleys – as they were known – were almost universal in those days. At Baldock someone came up with an idea that was to put these improvised toys on the map in quite a big way. When events were being planned for the Festival of Britain and Coronation celebrations, someone suggested staging a series of soapbox races for the local youngsters. These took place in a big car park alongside the town's main High Street and such

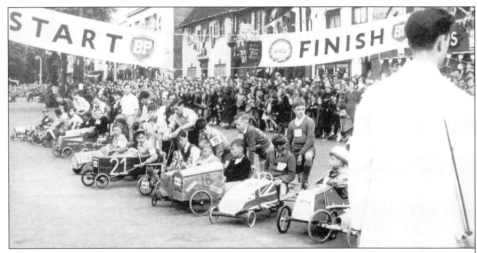

Lining up for the start of the Baldock soapbox Derby in the 1950s.

A cartoon by Giles appeared in the Daily Express *after he had been to present the prizes.*

was their popularity that they became an annual event. Within a couple of years, the Baldock Soapbox Derby was making national headlines and people came from far and wide to watch the races and spills that went on through the afternoon. One year the Derby was opened by the actor John Gregson, whose film *Genevieve*, about the London to Brighton car rally, was one of the most popular of the Fifties. In 1954, cartoonist Giles presented the prizes and featured a cartoon on the rally in the *Daily Express* the following Monday. He later gave the original drawing to the town and it hung in the council chamber for 20 years.

My own town of Hitchin contributed to the Festival of Britain celebrations in an even more ambitious way. The local Civic and Arts Association commissioned Cyril Swinson of St Albans, one of the country's best-known pageant masters at that time, to write and produce a pageant covering 900 years of Hitchin's history. It was a remarkable achievement for a town of less than 30,000 people and to this day remains the largest theatrical spectacle ever staged in the area. Presented against the backdrop of Hitchin's old priory, it featured 1,300 performers with many more working behind the scenes. More than 16,000 people came to see it, including The Queen.

The *Hertfordshire Express* ran a weekly column headed *At the Movies*. This gave readers a brief synopsis of films being shown at the local cinemas. Until television got a grip on family life, the cinema was our principal source of entertainment during the Fifties. 'Saturday night at the flicks' became a standard (and affordable) form of weekend escapism for many people. Every town in Hertfordshire, and even some villages, had at least one cinema. Some, like Watford and St Albans, were large enough to support two, three or four. Locally-owned enterprises were able to compete comfortably with the great art deco 'cathedrals of entertainment' built by big companies like Odeon, Gaumont and ABC. In Hitchin, the majestic Hermitage (demolished in 1964) had 1,400 seats and a superb tea lounge on the first floor. Apart from the interval ice cream, bought from the Lyons 'girl with the tray', people rarely ate food while watching a film – although they did chew gum and they did smoke. Oh, how they smoked! Throughout the performance a giant column of blue cigarette and pipe smoke would rise through the beam of light from the projector.

Whilst 'At the Movies', Mike Palmer of Letchworth urges us not to forget

those cinemas known affectionately as 'fleapits'. These were small, privately owned theatres that were usually in desperate need of new seats, new carpets and a coat of paint. Between 1939 and 1965 Mike lived in Huntingdon Road, Stevenage. He writes: 'One of my most enduring memories is of my weekly visit to the Publix cinema, which used to stand at the top of the bowling green, next to Tooley's Tuck Shop (where you could buy doorstep jam sandwiches and Cornish pasties). The Publix had been there since the silent days and showed its age ... The front stalls were 9d, but sitting there you risked wayward seat springs ending up in rather undesirable places. Rear stalls were 1s 6d (7½p), which is where my friends and I would go. The back row had double seats for courting couples. Unfortunately, some wag had unscrewed all the bolts holding the seats to the floor, so that when someone decided to ignore the film and kiss his girlfriend, the whole row would tilt backwards.

'The rear balcony seats were 2s. However, the projection room was so low that if anyone stood up to leave their seat their silhouette appeared on the screen ... Sometimes the film would run off the end of its reel before the projectionist had got the next reel ready, leaving a blank screen. This gave the more artistic members in the two bob seats the opportunity to treat the rest of the audience to a shadowgraph exhibition – rabbits, birds, butterflies and all sorts of other things!'

Another form of entertainment that survived the advent of television was the great British pastime of amateur dramatics. At the beginning of the war, in line with government policy, Hertfordshire towns set up entertainment societies, whose job it was to provide a range of concerts, variety shows and plays to bring wartime cheer to families, evacuees and servicemen in their community. In 1945, their work done, the groups were disbanded, but as some members wanted to carry on with this enjoyable hobby new dramatic societies and variety groups were formed. Most rehearsed in rented rooms and hired local halls for their performances but, as 'amdram' continued to flourish, some of the more adventurous organisations bought old church halls and, using mainly voluntary labour, turned them into little theatres. The Barn Theatre at Welwyn Garden City ran its own theatre from the beginning. One or two, like the Company of Ten at St Albans and the Bancroft Players at Hitchin, have since gone further and built substantial community theatres that are run entirely by volunteers and continue to thrive.

One of the Bancroft Players' productions caused some controversy in 1948; scandalous then, it now sounds truly quaint. One of the founder members, the late Maurice Keeley, once told me how he was producing *At Mrs Beam's*, a comedy set in a London boarding house. Most of the action takes place in the drawing room but there is one scene in a bedroom, in which a couple have a fight, during which the woman's dress is torn. There is some face-slapping and the occasional strong expletive such as 'You damned swine!'

Maurice, then an English teacher in a local school, recalled: 'One day not long after we had started rehearsals, I was taken aback to find myself summoned to the headmaster's office. Mr Herbert Ferrier, who was president of Hitchin Rotary Club that year, told me that he had heard from certain Rotarians that the Bancroft Players were about to perform a play that had a bedroom scene in it. As such, it appeared to be the sort of play that they felt should not be performed in Hitchin! Despite my assurances that there was no bed on the stage and that it was *a scene in a bedroom* rather than *a bedroom scene*, Mr Ferrier insisted that it would be diplomatic if I went along as guest speaker at the next Rotary lunch to talk about the place of drama in the community. Then I could reassure the Rotarians about the play.' Maurice duly appeared before his high-minded

The cast of At Mrs Beam's, the 1948 production that caused a storm in a teacup at Hitchin because of a rumour that it had a bedroom scene. Margaret Clarke is sitting on the settee wearing a floral dress.

fellow townsmen and assured them that the community would not be put in danger of moral collapse.

Margaret Clarke, of Garrison Court, Hitchin, who took part in *At Mrs Beam's*, told me: 'I remember the show receiving mixed reviews but the controversial scene did prove too much for Miss Mary Crystal, who was head of English at the Girls' Grammar School. At the interval she marched her party of girls out and did not bring them back!'

Another prerequisite to enjoying a social life in the Fifties was the ability to dance. In those days when most schools were single-sex, one of the few occasions when fraternisation between boys and girls was approved of was at sixth-form dancing classes. At my school these took place on Friday evenings during the autumn term, when senior girls were allowed to come to classes at the boys' school. As the girls sat in a line on one side of the hall, the boys on the other, Victor Sylvester and his Ballroom Orchestra would strike up on the school record player. This was the cue for the boys to rise, cross the floor and, with a self-conscious bow, ask the girl sitting directly opposite whether he might have the pleasure of this dance. The girls would rise demurely and advance cautiously into their arms and the nervous couples would find out to their surprise that the steps they had been practising separately actually worked when put together. We learned the quickstep to 'Rudolph the Red-Nosed Reindeer' and the waltz to 'When You Grow Too Old to Dream'. This

Joan Cook (left) and the Beryl Hunter formation dancers of Hemel Hempstead.

handful of lessons reached its climax with a sixth-form dance just before we broke up for Christmas.

Many young people continued with lessons after leaving school, either at youth clubs, evening classes or private dance studios. Kathleen Hardy remembers the excitement of going to classes in St Albans. 'They were held in a proper dance studio above Fosters Menswear Shop in Chequer Street – now Rymans,' she writes. 'Our teacher was the very dapper and courteous Frank, who was not a tall man but who held himself with all the grace of a ballet dancer. Rumour had it that he had been a boxer before opening the Verity School of Ballroom Dancing.

'I was quite tall and slim and I wore a black moire taffeta skirt with a freshly ironed broderie-anglaise sleeveless blouse. We also had to wear dancing shoes that were buckled so that they didn't slip off the foot as a court shoe would have done ... You floated majestically round the room with your mirrored reflection gazing back at you.'

Joan Cook belonged to the Beryl Hunter School of Dancing at Hemel Hempstead and was a member of the Hunter formation dancing team that competed in local competitions. 'We always made our own dresses,' she writes. 'They were very simple, made of blue taffeta and worn over the full frilly petticoats that were popular at that time. Our formation team used to be invited to give displays at lots of local dinner-dances, especially at the Kings Arms at Berkhamsted. Every year we used to take a coach to the Empire Ballroom in London to watch the finals of the

Dinner dance advertisement, 1965

Two advertisements linking indulgent foods with music and dancing

national championships … That was a great evening out because, when the championships were over, everyone could join in dancing to a really top-class band.'

American square-dancing became very popular; the men wearing check shirts, neckerchiefs and jeans, the women in blouses, flared skirts and swirling petticoats. Recalling the petticoat craze of the Fifties, Mrs Freda Mudd, of Benington writes: 'One of the funniest things I remember was the way we would make our petticoats stiff. Because we couldn't afford starch, the younger girls would soak them in sugared water instead and then hang them out on the line to dry. We couldn't understand why, within minutes, they were covered in insects.'

Frilly petticoats had come in with Christian Dior's New Look in 1947. After years of clothes rationing and drab, square-shouldered utility clothing, women went wild about the new fashion. To them it conveyed romance, the glamour epitomized by tiny waistlines and the full, billowing skirts dropping below the calf. Although there were critics among the men – Junior Trade Minister Harold Wilson described the fashion as 'irresponsibly frivolous and wasteful' – most greeted the fashion with delight.

Young men had less to be proud of fashionwise. Having thrown off the school uniform and eager to 'make a statement', some dallied briefly with dark brown 'drape' suits – 'nigger brown', as the colour was still being advertised in those days. The jackets, double-breasted with huge lapels and done up with just a single button, were worn with yellow shirts and brown ties, yellow socks and thick crepe-soled shoes known as 'brothel-creepers'. To the relief of our parents, they didn't last long. It was time for the working class lads to upstage everyone with the outrageous Teddy boy image, their hair cut like Elvis Presley or film star Tony Curtis, with his coy little DA (duck's arse) bob.

Ray Burdett of Baldock and Cliff Dear of Letchworth tell of a series of memorable pop concerts which they staged at the old John

Sheepskin coats became a popular fashion for the more affluent in the 1960s.

Goodenday Centre at Baldock to raise money to buy new kit for their football team. 'It seems unbelievable now,' writes Cliff, 'but at the end of the Fifties and in the early Sixties you could book most of the top groups for just a few hundred pounds. We had Johnny Kidd and the Pirates, The Who, and even The Rolling Stones.' Ray Burdett said: 'I shall never forget the night we had The Stones. We got them for £325, having turned down The Beatles because they were £25 dearer. We charged £2 for tickets and, when we turned up to let the audience in, there were something like 2,000 people waiting – which was a bit embarrassing because the centre was licensed for only 358!'

To take us out of this era, a final, colourful, memory (or perhaps it should be a confession) from Babs Bradley, who had arrived in Stevenage New Town with her family in 1957: 'By the 1960s our children were settled at school and were far better behaved than their parents. We were disgusting! We would leave them asleep in their beds to climb over a wall into the school grounds and have naked bathing parties in the swimming pool. Once, we were chased by the police, and as I was being helped back over the school wall I realised that the man helping me over was a policeman. He still had his uniform tucked under his arm. It was all in the local paper but fortunately there were no names or photographs! Whenever we had a party, it would stop at 11 pm so that we could watch *That Was The Week That Was* on BBC Television and then continue on to the early hours. When we had a fancy dress party one Saturday, a young man who arrived in police uniform turned out to be a real bobby who had come to tell us that neighbours were complaining about the noise. We invited him in and he stayed for three hours!'

The permissive Sixties had arrived.

Hertfordshire brewed its own cider in the 1950s.

CHAPTER NINE
SOME SIXTIES MEDIA MEMORIES

N owadays the public is fairly blasé about media folk. Camera crews and reporters wielding microphones are accepted (with reluctance by some) as part of everyday life. Back in the Fifties and Sixties it was a different story. There was tremendous excitement among local communities whenever radio comedians like Cardew 'The Cad' Robinson and Wilfred Pickles visited Hertfordshire factories with *Workers' Playtime* and *Have a Go* or when broadcasting icons like Richard Dimbleby and Franklin Engelman came *Down Your Way* to interview interesting local people and invite them to choose a record for the Sunday programme. In 1957 during a train drivers' strike my editor sent me hotfoot to Hitchin railway station to cover – not the strike – but a visit by a *Panorama* film crew who were making a programme about the dispute.

Over the next few years my BBC 'Midget' tape recorder – the first *portable* model – and I travelled the county reporting on issues of local and national concern. One story in particular turned out to be so interesting that

Down on the farm. The author with the BBC's first 'midget' portable tape recorder 1959.

it became a 25-minute programme in its own right. The subject was the arrival in Britain of an American-style self-service food store known as a supermarket. One of the first to open over here was at Watford. It created a lot of interest at the time, even though it was quite a small one. As Ann Waine mentioned in an earlier chapter when recalling childhood days in Watford, this was a time when housewives still made up a weekly shopping list for the grocer, who would then deliver the order by van the next day; when the women bought only necessary items and thought carefully before indulging in special treats and luxuries. Consequently, the series of interviews that I obtained with housewives as they came away from the supermarket checkout surprised my producer and the listeners. In almost every case, the women admitted that they had bought at least three times as many items as they had on their shopping lists. Being able to resist buying something displayed in a shop window was one thing, but to walk by a tempting item on the supermarket shelf without popping one into your trolley was a lot more difficult! Impulse buying had arrived.

Another story that illustrates how our society was discarding old values for the hedonism of the 'Swinging Sixties' happened in Letchworth at about the same time. Today, the garden city has its fair share of drinking palaces – from hotels and wine bars to designer pubs. However, forty years ago it was famous for being England's one and only 'dry' town – so, when the owners of a hotel in the town centre applied for a new licence to open their bars to the general public, the outcry could be heard across Hertfordshire and beyond. Letchworth's founder, Ebenezer Howard, had developed his garden city concept at the beginning of the 20th century to offer a new and healthier lifestyle for people seeking escape from the squalor and overcrowding of the industrial cities. Alcohol – 'the Devil's poison', as it was dubbed by the temperance brigades – was considered a prime cause of the misery in those areas, so Howard and his supporters decided that there would be no public houses in the city. Apart from one token hostelry called The Skittles, which served only non-alcoholic drinks, Letchworth had remained a publess zone for the first sixty years of its life. So, when the hotel's licence application came before the magistrates, there was strong opposition from the traditionalists. The story is memorable to me because it was the first that I reported for television.

I drove into the rain-swept car park of the Broadway Hotel, Letchworth one dreary morning, very much aware that a career in television hinged on my

day's work. I had no idea who I would be working with but I found two of them in a corner of the car park huddled glumly in a mud-spattered grey Ford Zephyr: Gerry Rowley, the cameraman, and his sound recordist, Peter Matthews. There was no sign of the director.

After half-an-hour, and still no director, Gerry announced that he would direct the film himself. He set up his tripod and camera and took several shots of the exterior of the hotel before my first interviewee arrived. Pedalling into the car park on an enormous and very ancient bicycle came the spokesman for the opposition, Mr Harry Meyer – one of the original spartan breed of pioneer garden city residents – a teetotal, vegetarian naturalist of somewhat eccentric appearance, who wrote a *Flora and Fauna* column for the local paper and could be seen in mid-winter pedalling around country lanes wearing a summer shirt, shorts and open-toe sandals.

Having completed the interview to Gerry's satisfaction, we moved inside the hotel to set up for what's known as the 'piece to camera', that part of a film where the reporter is seen addressing viewers, usually against a background related to the story he's reporting. On this occasion the obvious location for me was on a bar stool, pint in hand, which I would quaff enthusiastically before turning to the camera to begin my piece.

Filming an interview with a campaigner against 'the Devil's poison' in Letchworth Garden City, 1961.

When that ordeal was behind me, I settled down to enjoy myself, but the enjoyment was short-lived. As I turned to pick up my pint the bar door flew open and in strode our missing director, Peter Kennelly, an hour late. After a loud and very public clash of artistic temperaments between Gerry and Peter over why Gerry had started filming before the director arrived, why the director hadn't turned up on time and whether we should start filming all over again, as he had no way of knowing what had been shot so far, Mr Kennelly had me doing my pint-swigging piece to camera five more times – each time from a different angle and each time with the glass topped up. Now, I do not have a large capacity for beer and the amount that I had consumed during the course of filming this sequence was beginning to affect my speech and my bladder. Mercifully, I was able to keep control of things until the lunch break, after which I completed the out-of-vision commentary sitting in the comparative quiet of the camera car.

I went home nursing a bit of a hangover and a feeling of anti-climax. I was certain that, what with my anxieties and inexperience, the wet weather and the row involving the crew, the whole day had been a disaster. I needn't have worried. *Town and Around*'s editor rang the next day to register fatherly approval of my first efforts, and when the results of our work were broadcast that evening the end product turned out to be a pacy and entertaining four minute report, of which even I – my sternest critic – felt rather proud.

Here now are some recollections of other Hertfordshire 'media folk' who have kindly spared me time to reminisce about their younger days and life in the county.

BOB WILSON

In 1963, when TV's sports presenter Bob Wilson first got to know Hertfordshire, a job 'on the box' would have been the last thing he had in mind. That was the year that Arsenal's manager, Billy Wright, signed him up as a goalkeeper for the legendary 'Gunners' and introduced him to a piece of near-idyllic Hertfordshire countryside where he was to spend much of the next 40 years of his life. These were the playing fields at London Colney, belonging to University College London, which Arsenal hired for their training ground until quite recently, when they opened their own state-of-the-art training HQ on adjoining land.

Bob Wilson training in the 1960s.

Bob, who lives at Brookmans Park, near Hatfield, told me: 'In the 1960s the training ground was a beautiful spot. Out in the country, secluded and traffic-free. You couldn't wish for a better location. However, the dressing rooms and toilet facilities were another matter. Primitive to say the least! Parts of it reminded me of a scene from a prisoner-of-war camp. When the squad came off the field after a training session, covered in mud and scrapes, we would have to wash ourselves in old tin baths filled with lukewarm water. Unfortunately goalkeepers are usually the last off the field after these sessions, so by the time I got to a bath, three or four of the other lads had been in before me – and by then the water wasn't a pretty sight. I had to have a shower afterwards to wash off the things I'd picked up in the bath!'

In the photograph Bob Wilson and his captain, Frank McLintock, are seen leading Arsenal's First XI squad on a pre-season training run at the London Colney playing fields in the 1960s. Sadly, a similar photo taken today would show M25 traffic rattling along on the far side of the field behind them.

After nearly 12 years as Arsenal's goalkeeper, a bad knee injury forced Bob to end his playing career at the age of 33. He turned to coaching and it was

during that year of 1974 that he noticed how the champion Brazilian team was operating with not just one coach but two or three, each specialising in a different aspect of the game. He suggested that the idea ought to be adopted by British football and, as a result, sparked a change in the whole approach to football training in this country. Bob was appointed Arsenal's goal-keeping coach in the same year and remained with them until his retirement in May 2002.

The Arsenal FC logo.

Bob's broadcasting career began on the BBC's *Sportsnight*, in 1974. Now retired, he remembers occasions when the joint careers of football coach and television performer put him under considerable pressure. 'I think the hardest time was when I was signed up to present sport on the BBC's new *Breakfast Time* show,' he told me. 'I had to leave home at 3.30 am to drive to the Lime Grove studios. Then at 9 am, when we came off the air, I would have breakfast and go straight to the training ground at London Colney to coach the Arsenal players until the middle of the afternoon. I survived that routine for 12 years. How, I shall never know!'

JOAN MORECAMBE

It was a chance remark from a plumber that brought one of Britain's best-loved comedians to Hertfordshire in the 1960s. Eric Morecambe's widow, Joan, remembers the moment as though it were yesterday. 'In 1961, we were living in a semi-detached Victorian house in North Finchley. We had converted it into two flats, then sold the top one and lived in the other,' she

Eric and Joan Morecambe and their children Gail and Gary catching up on the local news with the Herts Advertiser *in the 1960s.*

recalls. 'At that time we were looking to build our own house because our second child, Gary, was on the way. We wanted to find somewhere more secluded, in the countryside, but couldn't think where to choose. One morning a plumber working in the flat overheard us talking about this and suddenly said: "Try Harpenden." We told him we had never heard of the place but he assured us that it was a very pretty village near St Albans. As Eric wasn't working that day we decided to jump in the car and take a look for ourselves. Once we had seen the lovely common and had a cup of tea in one of the little tea shops we knew it would be ideal for us. Then we found that a local development company was building homes in a perfect spot overlooking the countryside and before you could say "Jack Robinson" our minds were made up.

'We were pleased to find that there were also some really good schools in the village. Gary went to Mrs Prime's Infants School when he was five and our daughter, Gail, spent all her school days at St George's, an old-established private school that is still thriving today,' Joan said. The fact that the M1 had just opened meant that the family were close to a direct route north to Lancashire, where Eric's parents lived, and only a short drive south to the Elstree Studios, where the Morecambe and Wise shows were then being recorded.

Eric and Joan's first Harpenden home was built to their own design and they remained there until 1967, when they had the opportunity to move to one in a more secluded spot. Because Eric's work sometimes took him away from home for long periods, he became all the more appreciative of life in Harpenden, Joan believes. 'He liked nothing better than to wander down to the shops and potter about chatting to people and browsing in the book stores.' As Gary got older, Eric wanted to find an interest that father and son could share, so the two of them decided to support a local football team. 'They couldn't make up their minds whether to go for Luton Town or Watford,' said Joan. 'So they literally tossed a coin and – as every Morecambe and Wise fan now knows – it came down Luton.

'Eric began to enjoy the tranquility of the surrounding area even more after he had suffered his first heart attack. That was when he decided to take up bird-watching to get out and about on country walks. He would go off with his binoculars and became quite an expert at identifying different species.'

BARRY NORMAN

In 1959, Barry and Diana Norman decided to forsake 'the flat life' of London and head for the country. They opted for the village of Datchworth, a few miles north of Hertford, where they bought a block of four derelict cottages, which they converted into a single property. They had no children at that time and their plan – one pioneered by many young professional couples in the Fifties – was to live in the house for a year or two, sell it for a good profit and move on to something larger. But, so much did they enjoy the experience of living in a rural community that – more than 40 years later – they are still there.

'As with most villages, the social life of Datchworth revolves around three places – the church, the cricket club and the pub,' said Barry. 'As we embraced all three, it wasn't long before we found ourselves swept into village life. The cricket club met in the pub, which was where I got to know them and was eventually invited to play in a match. They were particularly interested when they found out that I owned a car. This seemed to guarantee my selection for the team whenever there was an away match! When the club decided to build itself a new pavilion, members did all the work themselves. I spent a day labouring for them and still feel a certain pride each time I walk by.'

One of the broadcaster's biggest regrets is that the Hertfordshire accent has all but disappeared. He recalled an incident when a delivery man, having stopped to ask a local if he knew where a certain customer lived, had driven round looking for Arkensal Lane. It was quite a while before someone realised that the villager had directed him to

Barry Norman describes this as 'a rare picture' showing him skiing at Kitzbühel in Austria during his days with the Daily Mail *in the 1960s.*

Hawkins Hall Lane! And in these days when hedgerows are not cut but 'ripped' by machines resembling mechanical diggers, he mourns the disappearance from his village of such craftsmen as hedgers and ditchers, who made ten times better work of the job, equipped only with a billhook and a spade.

'When we moved into our restored cottage in 1959, our neighbour was a hedger and ditcher,' Barry said. 'Bill White and his wife, Betty, lived in the next cottage, which had no electricity supply. Bill had fought in the Great War and been taken prisoner. Incredibly, Betty had never been to London, even though it is only 30 miles away. She used to babysit for couples in the village and one of our friends told us that, when they came home one night, they had found her sitting in the dark. She hadn't liked to switch the light on because she wasn't sure how it worked!'

ZENA SKINNER

Cookery expert Zena Skinner, who lives in Redbourn, has – like me – some

fond memories of her first broadcasts on *Town and Around* in 1963, during the programme's pioneering days. 'I prepared the first meal on a small grill and plate that the studio engineers had borrowed from the fireman's hut,' she said. 'It all seemed very casual to begin with. First, the editor asked me if I could do one spot a week for three weeks, then for the next three months and so on. After that it just went on and on for five years. Yet, in all that time they kept paying me on a weekly basis. I was never put under contract.' Because she was working on a news

A Zena Skinner cookery book from the 1960s.

TV technicians ensured there was no shortage of volunteers to sample Zena's cooking after the programme.

programme, Zena had to make sure that her recipes had a topical theme. 'I rang all the main London markets each week to find out what food was in the news and then worked out a recipe using it. I would spend three days at home preparing the script and testing recipes on my mother and the neighbours. If they gave one the thumbs down I would have to start again.' On the day of the programme Zena would prepare three sets of ingredients – one for a run through, one for a dress rehearsal and the third for the actual take. 'Although I was offered help, I decided that – as housewives have no helpers – it was only right that I should do everything myself as well,' she told me.

Eventually, Zena's programme began to influence housewives' buying habits across the region – to the extent that local butchers and fishmongers began asking her to let them know what dish she was preparing each week. 'One week I heard that bakery workers were planning a national bread strike so, in case it happened, I decided to do a bread-making recipe,' she said. 'The night the programme went out the strike was announced on the news and the telephone switchboard at Alexandra Palace was jammed by viewers trying to get details of my recipe.'

DORIAN WILLIAMS

One sport which surprised even the programme makers by achieving enormous popularity during the 1960s was showjumping. Just as town

centres would empty on the Saturday afternoon that the Cup Final was being played, so pubs would empty in the evenings as people hurried home early to catch the *Horse of the Year Show.*

For a long time the 'voice' of that BBC show was a Hertfordshire man – the late Dorian Williams, of Pendley Manor near Tring. Then Master of the local Whaddon Chase foxhounds, Dorian (pictured with his wife Jennifer and a couple of friends) had been introduced to horses at a very early age. When he was just three, his father, due to go off to the Great War, said he wanted to see two things before he went: Dorian riding a horse and Dorian christened – in that order! Once asked the reason for the sudden popularity of showjumping on television the commentator suggested two: that viewers found it a refreshing change from the 'over-mechanisation' that now dominates life and

the fact that the camera is able to capture everything that matters – horse, rider and fence – in one shot.

Dorian's other significant contribution to the Hertfordshire arts and entertainment scene was founding an annual Shakespeare festival on the lawns of Pendley Manor, which to this day can attract audiences of up to a thousand a night.

The 1960s show-jumping commentator Dorian Williams, his wife Jennifer and friends at Pendley Manor, Tring.